POST-SOVIET
ART AND ARCHITECTURE

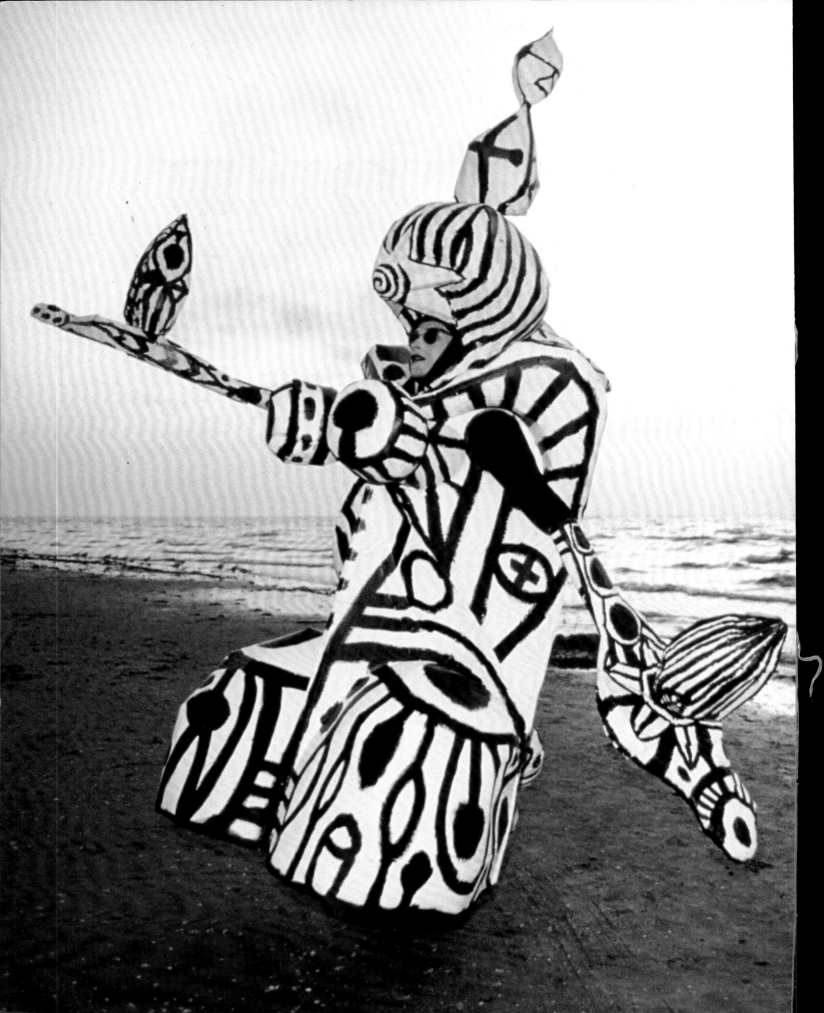

POST-SOVIET
ART AND ARCHITECTURE
EDITED BY ALEXEY YURASOVSKY AND SOPHIE OVENDEN

A.D. ACADEMY EDITIONS

ACKNOWLEDGEMENTS

We must thank Dr John Biggart of the University of East Anglia (Norwich, England), the authority on early Soviet history, for his help in organising the international conference/exhibition on Post-Modernism and national cultures which was held at the Tretyakov Gallery, Moscow, in October 1993. But for his unprecedented energy and zeal, the conference would never have been launched, and this book largely based on its material would never have been written. We also owe a great debt to the British Council and its Moscow representative Victoria Field for a generous donation to the conference which has kept the whole idea afloat. *(The Editors)*

NOTES ON CONTRIBUTORS
Charles Jencks, writer, broadcaster and lecturer, was the critic who first defined post-modernism in architecture, an event which led to its subsequent definition in many of the arts. Alexey Yurasovsky is an archeologist, historian and translater, currently foreign editor at the *Central Journal of Russian History*, he lives in Moscow. Sophie Ovenden is a freelance editor, based in Moscow, she is currently working at the *Moscow Times*. Elinor Shaffer is a reader at the University of East Anglia and edits *Comparative Criticism*, Cambridge University Press. Lisa Appignanesi was formerly Deputy Director of London's Institute of Contemporary Arts, her most recent books include the novels *Dreams of Innocence* and *Memory and Desire*. Natalya Kamenetskaya is an artist and the editor of *Idioma*, a feminist publication. Yury Leiderman is an artist and art critic. Sergey Orlov is an art critic working at the Russian Academy of Arts, Moscow. Alexander Rappaport is a Russian architect living in London. Evgeny Semyonov is an artist living in Moscow. Lana Shikhzamanova, Nadezhda Yurasovskaya and Olga Yushkova are art historians and curators at the Tretyakov Gallery in Moscow. Evgeny Solodkii is an artist living in Saratov. Alexey Tarkhanov is the editor of *Kommersant* and a professional architect. Andrey Tolstoy is an art historian working at the Russian Academy of Arts, Moscow. Olesia Turkhina works at the Russian Museum, St Petersburg and Viktor Mazin is a philosopher. They are the editors of the journal *Kabinet* in St Petersburg. Olga Ziangirova is an artist and runs a gender centre at the State Humanitarian University, Moscow.

Translations from the Russian by Alexey Yurasovsky ('It's only a Paper Moon' translated by Alison Cowe)

Front Cover: The White House, Moscow (photomontage by Charles Jencks and Jason Rigby)
Page 2: Andrey Bartenev, Uncle Plum on the coast of the Baltic Sea in Iurmala; *papier-mâché, photo Yury Kozyrev; Pages 6-7: Peter Karachentsov,* The Servants of Astrea, *1990, oil, massonite, 86x140cm; Pages 32-33: Valery Eisenberg and Irina Danilova,* Aphrodites of Ovules, *October 1992, installation of eggs, wood, plaster, Central House of Artists; Page 31: photo by Igor Manoukian*

First published in Great Britain in 1994 by
ACADEMY EDITIONS
An imprint of the Academy Group Ltd
42 Leinster Gardens, London W2 3AN
Member of the VCH Publishing Group

ISBN 1 85490 375 6

Distributed to the trade in the United States of America by
ST MARTIN'S PRESS
175 Fifth Avenue, New York, NY 10010

Printed and bound in Italy

CONTENTS

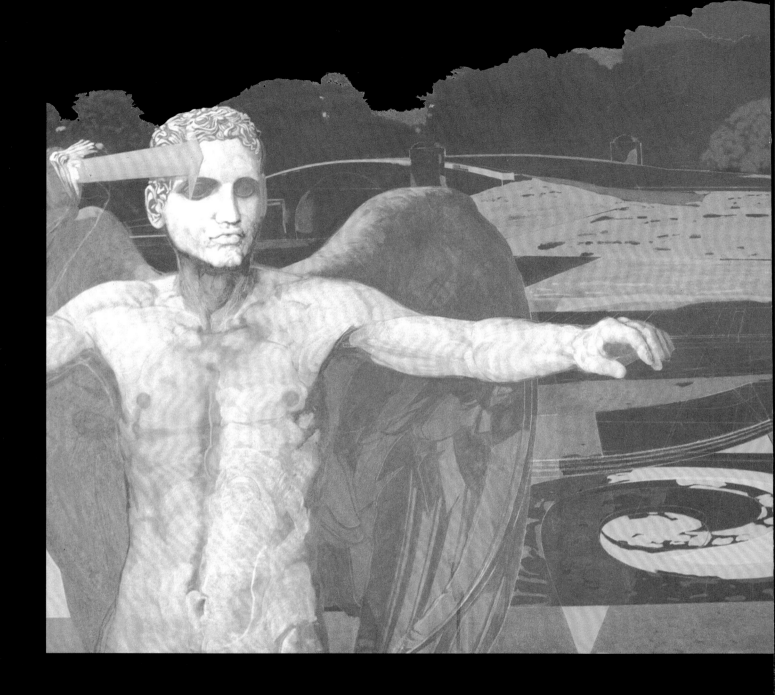

POST-MODERNISM
AND
NATIONAL
CULTURES

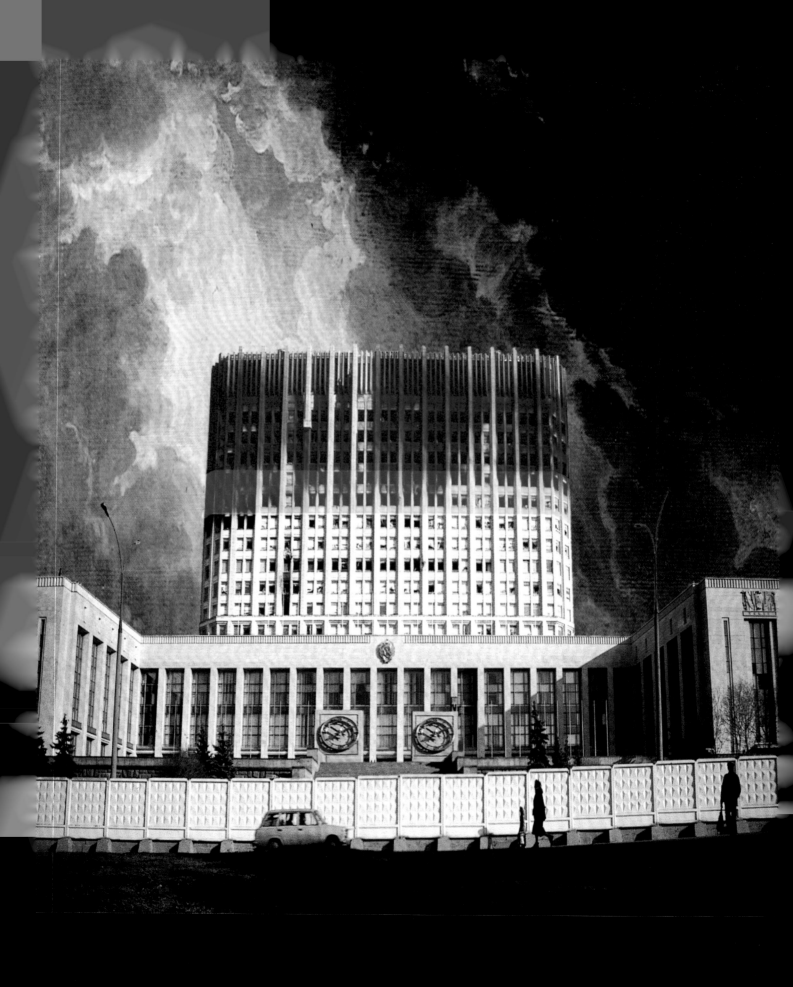

CHARLES JENCKS

MOSCOW, OCTOBER 4 1993 – 10.10AM
MODERNITY IS DEAD

Post-Soviet art and architecture are slowly emerging from the anarchy which is Russia and its former empire. This book, celebrating this painful emergence, is based on an exhibition and symposium in Post-Modernism held in the autumn of 1993. The art exhibited at the huge white Tretyakov Gallery, Moscow's old centre of official art, was ironically the first large display of post-modern art in Russia. The irony stemmed not only from the contrast between the bureaucratic modernism of the gallery and the personal, occasionally anti-Statist art, but also from the way all positions – modern, post-modern, totalitarian and libertarian – were displayed as 'art', appearing to contain similar if not identical meaning. Does the museum eat up everything – is this 'repressive toleration'?

Whatever the case, this retrospective was very important as it was the first of its kind inside the former Communist bloc, and because it revealed an artistic pluralism as vital, if not as wide, as that in the West.

Soviet Russia suffered Modernism and the modern paradigm more than any other country. With the possible exception of China, its forms of brutal materialism were more systematic than elsewhere and its imposition of a reductive rationalism and mechanistic mind-set more thorough-going. The utopian housing estates built as vertical concentration camps in heavyweight concrete were more ubiquitous, the secret police and mind-control more pervasive.

Given this depth of virulent modernity, it has taken longer for the Russians – in particular Gorbachev and Yeltsin – to unravel the system, and obviously it is not completely unstitched even now. Yet with the October *putsch* of Rutskoi and company, an important moment was marked and it was watched by the world, in a very post-modern manner on TV. Even around the Parliament building, there were more spectators than participants, more curious onlookers than sharpshooters. This 'Second October Revolution' was as much media event as real history. Perhaps in the end it will be more real for being so: now reactionary modernists all over Russia know the game is up.

Modernism suffered an architectural stroke at Pruitt Igoe, St Louis, 1972 and an ecological one at Chernobyl in 1987 – and many other such maladies have captured the headlines. However, the most dramatic haemorrhage that modernity sustained – dra-

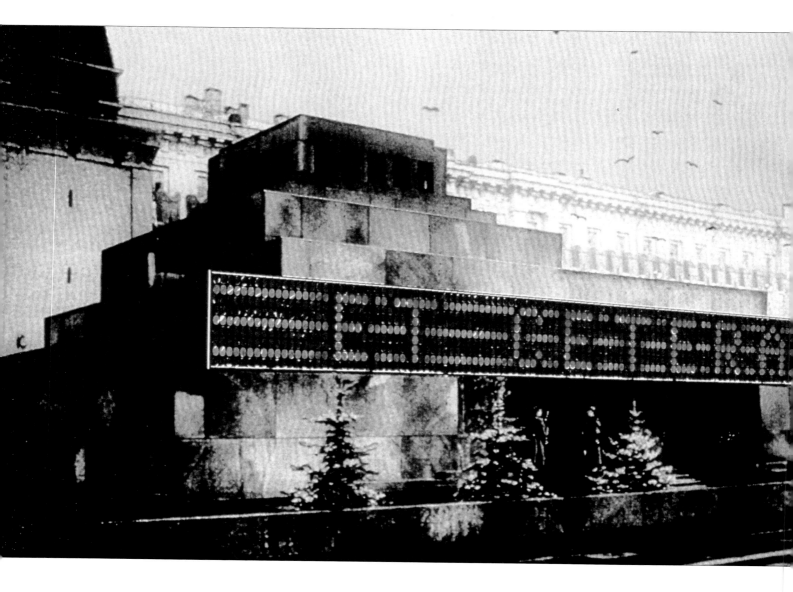

matic because it was a political and physical battle – occurred in Moscow on October 4th, 1993 at 10.10am. At this moment a fusillade from tank artillery stopped the golden clock – symbol of the Newtonian workaday world ('time is money') – sitting atop the old 'White House', and that dumb box of boring repression was turned half black as flames cut through its middle. The storming of the Bastille and the taking of the Winter Palace are memorialised landmarks of literature and architecture. Now, once again, the hated symbol of a power structure, presented in the reigning style, has had its meaning inverted by an act of civil unrest. Action changes the meaning of forms, and architecture memorialises such change more than any other art form.

The Black and White House must thus be redesigned with the memorable event clearly represented; it must celebrate the epochal change in paradigm and make a permanent landmark for future Russian history.

Mordant Moscow wits saw in the carcass the metaphor of Black and White Whiskey and the fruitless zig-zag between two extremes; others saw the proportions of the building improved, articulation and scale finally brought to bear on a modernist slab. As a charred ruin, the building has a poetic personality it never enjoyed as a pretentious monument, but the challenge is to redesign it as both a fitting symbol and functioning structure, something that mediates between a modernist past – which should not be denied – an unknown but hopeful future, and the post-modern present. Perhaps it should be a tripartite structure which keeps a memory of the shift in paradigm and yet still becomes a new whole. What would be unthinkable and cowardly (and for the moment has occurred) is that the building be simply refurbished, the cracks papered over and the whitewash brought out. The ultimate cover-up? Modernists will never admit it is all over.

Make no mistake about it, the modern paradigm – and its basis in reductivism, determinism, materialism and mechanism, the four great Newtonian '-isms' – is waning, even if the waning power structure denies it. The command economy enjoys the same place as socialism and the modern science of linear mechanics: they are all consigned to play small roles as parts of a larger, more holistic synthesis.

Not a day goes by without a new post-modern science, under the portmanteau theme of complexity theory, pounding another nail in the coffin of determinism. Quantum, Relativity, Systems Theory, Catastrophe Theory, Chaos – everyone but the modernists knows the litany that renders them marginal. Yet, as Max Planck complained, since it is usually not possible to convince one's opponents, one simply tries to outlive them. Thus, the post-modern paradigm progresses cheerfully, death by death, marking three of

the more notable funerals with architectural ruins: Pruitt Igoe, Chernobyl and, temporarily, the Moscow Black/White House.

Fortunately there are more creative means of progress, which brings me back to the Tretyakov exhibition and symposium. Here, and in the book, we find the main themes of post-modern painting parallel to those in the West: the emphasis on contrasting local identity with the international scene, particular provincial history with the universal. A strong double-coding colours most of this work, as it does Post-Modernism generally. There are several politically motivated satires – one portrays the grey mass: faceless bureaucrats and the power elite all unified in a sea of grey buildings and suits set off by red dots – badges of honour, lipstick or murder? There are the expected references to the failures of modernity – ecological destruction with post-Chernobyl art explicitly referenced. There are a few feminist works, some of high quality, focusing on domestic scenes, and paintings which intend a general spirituality without religion. Photo Realism, Conceptual Art, Post-Socialist Realist and Sots Art are all represented. A frustrating aspect of this pluralism, even with 391 objects on show, is that no individual, group or thematic development is presented in enough depth to be fully appreciated. A more critical and polemical focus would have paradoxically made the inclusivism stronger.

Post-Modernism has sometimes been confused with the Socialist Realism and the official art and architecture that were imposed by Stalin. The confusion is caused by the fact that some forms of realism are common to both and, as cultural periods, they both occurred after the heyday of Russian Modernism, 1890-1930. Their goals and styles, of course, are entirely different. Socialist Realism is wide-eyed, and the enforced idealism of modernisation; Post-Modernism is ironic, dually-coded and resistant to reigning power. They both may seek to be popular, but only Post-Modernism uses various codes to cut across different taste-cultures.

Komar and Melamid show these distinctions in their Sots Art (Social Realism as Pop) produced over twenty years. The earlier work, such as *Stalin in Front of Mirror*, mixes the conventions of Socialist Realism, Chardin, religious painting and Malevich's *Black on Black* – that is codes of several periods. Taken together, these poke fun at a Stalin praying, reflecting on his mistakes and making-up in front of a mirror – with bare feet. Komar and Melamid's *Lenin Mausoleum Project*, part of the 'What to do with Monumental Propaganda' project instigated by the artists in 1993, makes another ironic comment contrasting ephemerality and monumentality. Lenin's mausoleum remains for eternity to broadcast the merry-go-round of leaders, symbolised by the computerised bulletin board announcing ET CETERA.

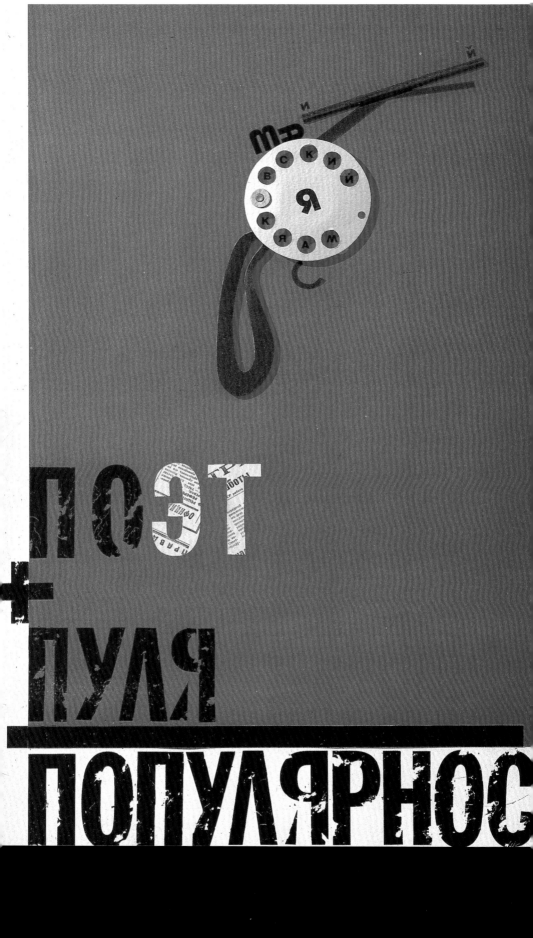

МАЯКОВСКИЙ

ПОЭТ

+

ПУЛЯ

ПОПУЛЯРНОС

Komar and Melamid, like other Russian Post-Modernists such as the architects Brodsky and Utkin, have been developing a new, critical language based on narrative. Telling stories, producing elaborate social and personal narratives, is an important way to organise disparate and changing material, so one is bound to see it continue in Post-Soviet culture for some time. Yet these narratives have not quite coalesced into a mature, shared culture.

It also has to be said, and this is not to criticise Post-Modernism in Russia more than elsewhere, that there is still no great work of art revealing the new paradigm as a whole. Modernism took many years before it produced its twentieth-century masterpieces – *The Waste Land*, *Guernica*, the Monument to the Third International, the Bauhaus, *Le Sacre du Printemps* and so on. It would be surprising if the new world view, at so young an age, produced work of this quality and depth.

Yet the paradigm is clearly coming into focus at many levels and, driven equally by the new sciences of self-organisation and the new liberation movements bent on self-organising democracy, a mature synthesis is now becoming possible. It might be attained in some regional centre, such as the Baltic states (which are given a separate room at the Tretyakov), or by a group or an individual. But the pressure of many different artists pursuing the emergent themes of this growing international culture – made conscious of each other through such exhibits – is likely to increase competition and force some onto the next step and deeper ambition.

p8 The White House, Moscow, (photomontage Charles Jencks and Jason Rigby)

p10 Komar and Melamid, ET CETERA, *Lenin's Mausoleum Project*, 1991-93, hand-coloured computer graphic (Ronald Feldman Fine Arts, New York)

p12 Komar and Melamid, *Stalin in Front of Mirror*, 1982-83, 182.8x121.9cm, photo D James Dee (Ronald Feldman Fine Arts, New York)

pp14, 16, 17 Andrey Voznesensky, the poet and architect who along with Yevtushenko received great prominence in the 1960s, had an exhibition of collages and a public reading during the events that surrounded the Post-Modern exhibition. His collages are a dramatic and humorous use of Constructivist techniques of photomontage, abstraction and typography. Portraits dominated, the Constructivist poet Mayakovsky is symbolised by his own blood red and black graphics (p14), letters from his name making a pistol and telephone dial with a bullet (perhaps signifying the poet, the bullet of the populace), he shot himself after making numerous telephone calls to his friends. One of the first Soviet victims, he has become another sign of Voznesensky's Post-Soviet art. Isadora Duncan, whose famous death was caused by her scarf, is represented by this and a rope (p16); Madonna was the simplest, Madonna with her finger pointing to the centre of attention – the crotch of the M (p17)

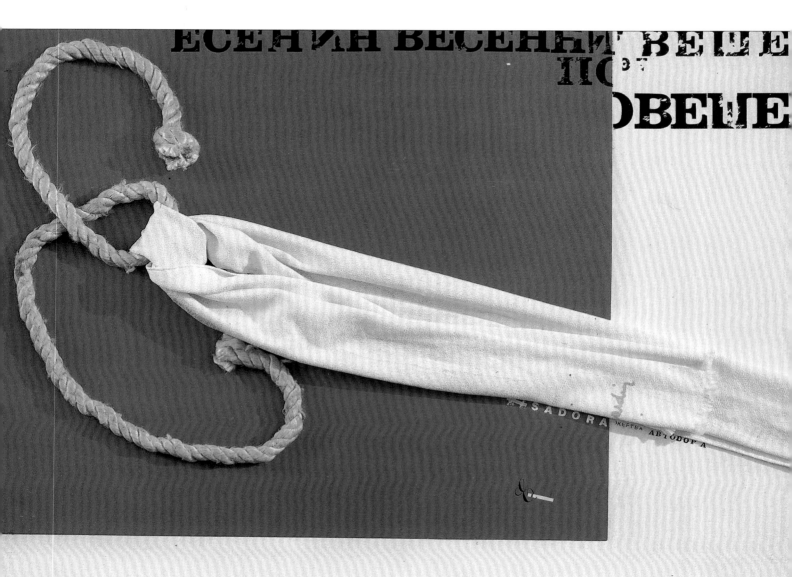

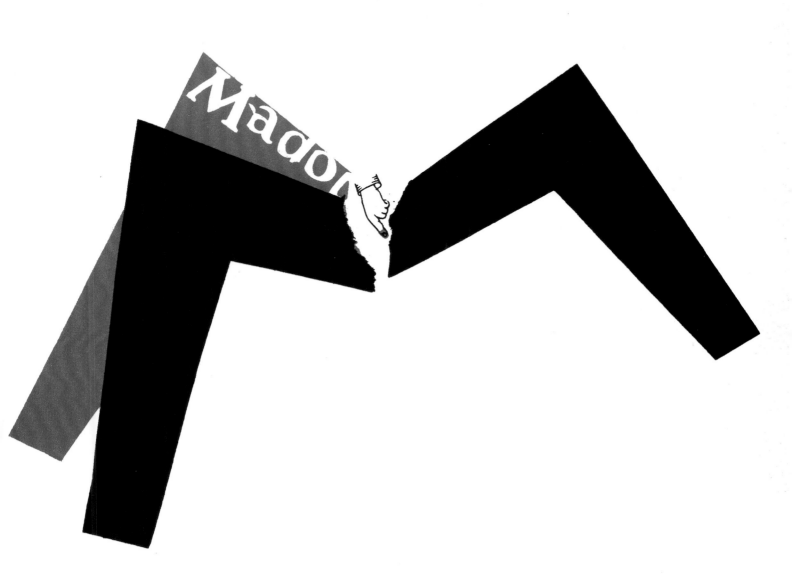

ELINOR SHAFFER
APOCALYPSE AND UTOPIA THROUGH POST-MODERN EYES

In 1917 there was a zeppelin raid on London. Yevgeny Zamyatin, the Russian science fiction writer, described it in *The Fisher of Men*:

> Something had happened. The black sky above London burst into fragments: white triangles, squares and lines – the silent geometric delirium of searchlights. The blinded elephant buses rushed somewhere headlong with their lights extinguished. The distinct patter along the asphalt of belated couples, like a feverish pulse, died away . . . The silence swelled out for a moment, stretching like a soap bubble and then burst. Far away bombs began to whine and stamp with iron feet. Growing taller and taller, reaching up to the sky, a delirious truncated creature – just legs and belly – stupidly and blindly stamped the bombs onto the ants and their square anthills below. Zeppelins . . . [1]

Russia is one of our richest sources of apocalyptic and utopian literature and thought. It is not surprising that it is also the source of a powerful vein of anti-utopian satire which incorporates the apocalyptic hope and the utopian aim in the negation of that belief and that aim. We should expect, then, that post-modern art in Russian will have a more powerful resonance in Russia despite, or because of, the delay in its recognition. As early as 1917 Zamyatin used apocalyptic and utopian ideas in this way. In his brilliant pair of stories *Islanders* and *The Fisher of Men*, with an English setting – he spent 1916-17 in England supervising the building of ice-breakers for Russia in the Newcastle dockyards – he satirised them by placing them in an inhospitable setting in which they were scaled down to size; but at the same time the disproportion acts as a potent satire on the English, whose insularity, hypocrisy, social conventionality, and masked prurience are savagely revealed by contrast to the world war and revolution which formed the backdrop to the stories. In the English setting, the apocalyptic event of the zeppelin attack becomes a screen for the coupling of an unawakened wife and her peeping-tom neighbour:

> The delirious sky flashed momentarily. An absurdly thin black figure flashed against the wall. And the tender lips, lie a foal's, drew apart the curtain across Mrs Craggs' lips. There was only a minute left to live. [2]

Thus apocalypse is turned inside out: in the repressive English setting an apocalypse is required to enable a peccadillo to take place. But the apocalyptic event is also used as a representation of the exaggerated significance of the peccadillo in this social framework; and finally there is already a suggestion that the apocalypse and the amorous 'little death' are linked not by cause-

and-effect but by coincidence, as in the full-blown later post-modern fiction of Thomas Pynchon, *Gravity's Rainbow*, where again air attacks over London, this time in the Second World War, coincide with and are 'predicted' by amorous escapades.[3] These apocalypses turn the portentousness both of traditional apocalypse and of modern scientific prediction towards post-modern comedy. Lighthearted though these comic uses of apocalypse may appear, they reveal an important truth: the human will to believe that the End of the World is not the end of the world is as powerful as the hope or the fear of the End. 'The End of the World', as tradition-ally understood, is the end of the others, the enemy, the unworthy, the present oppressors – but not of ourselves. The end of the world ushers in a new world, preferably on earth. The con-vinced millenarian, as Norman Cohn has shown in his pungent way, believed that the Apoca-lypse would usher in a thousand year rule of the Saints – that is, the rule of the believers – on earth – before the Day of Judgement actually took place. The Book of Revelations sketched out this immensely extended scenario for 'the end'; and the Sibylline Oracles pieced into Revela-tions a still more elaborate account of the events of the Last Days, when the Last Emperor would face the Anti-Christ in his human or beastly forms.[4] The writer of the genre of apocalypse was by definition not a true prophet but one who prophesied the end before a date that had already passed at the time of writing.

The view that Post-Modernism is primarily a form of 'antirealism' leads to the useful notion that post-modern texts may deliberately be acosmic (aim at breaking up coherence and defeat-ing holistic or unified world-making strategies), but that equally they may after all be neocosmic in so far as worldmaking is understood as a form of fantasy that helps to grasp 'otherness'. Thus traditional concepts, apparently banned by Post-Modernism, find their way back again: 'the intentional use of the uncustomary' may account for the emergence of 'such narrative phenom-ena – which it was Realism, after all, that persuaded us were "naive" – as saints, villains, abso-lute mystery, absolute creation, treasure, apocalypse, glory, pure evil, final victory, universal annihilation, divinity, hell, and heroism.'[5]

World-making of course embraces the traditional notion of aesthetics; but so does 'play' in drawing attention to the 'caprice' or world-making-and-breaking capacity of the author (or text), as Friedrich Schlegel formulated it for Romanticism. But the playful acosmic and the world-making fantasies may be combined. Thus at least some of the myths and 'grand narratives' that Jean-François Lyotard claimed had passed away with Post-Modernism still survive within it. However, because of the 'incredulity towards metanarratives' that defines Post-Modernism for Lyotard, the traditional narratives that are readmitted may be handled in surprising ways.[6] Apocalypse offers one example. I shall particularly point to the way apocalyptic time may be handled in a post-modern context.

In fact, few literary treatments ostensibly of 'the end of the world' actually end with the end. As Eric Rabkin points out in his essay 'Why Destroy the World?', 'There are virtually no tales of the end of the world in which all of creation ends.'[7] Rabkin goes on to relate, for example, the famous Arthur C Clarke science fiction story, *The Nine Billion Names of God*, in which an American expedition to Tibet gave the monks who are counting the names of God a computer. The monks' belief is that the world will come to an end when all the names of God have been counted. The American experts, departing down the mountain in a hurry for fear the monks will be angry when nothing happens, see the stars going out one by one. As Robert Galbreath points out in his interesting essay 'Ambiguous Apocalypse', however, even this need not be the end of the world – except perhaps for the computer operators.[8]

If, however, in the millenarial scenario the world does not end but only *this* world, or even this era or phase of the world – if the world ends only to be renewed or replaced, introducing radical discontinuity but not the definitive end, its renewal may be envisaged in a variety of ways. Even after the Last Judgement itself (returning to the Book of Revelations scenario), it is a new world that comes: the New Jerusalem, which may be interpreted as transcendent, or once again as secular. The New Jerusalem has no End.

If the traditional apocalypse or unveiling or, simply, disclosure reveals and signifies as much the new beginning or renovation as the end, in our own time the apocalyptic end is primarily a natural one, or one predicted or explicable by science, and is often defined simply as a catastrophe or violent destruction. In this simplified and reduced scenario we have considerable if reluctant faith. The utopian hope of renovation, by contrast, the 'anticipation of the sunburst', a phrase from William Morris' *News from Nowhere*, but appropriate too to the immense burgeoning of optimistic science fiction in the Soviet 1920s, is, at the moment, at a very low ebb.[9]

Yet even in the reduced 'natural' scenario, tropes of postponement flourish, and closure is forestalled. Indeed, this may be an unspoken or displaced aim of the familiar avoidance of closure in post-modern texts which looking squarely at a traditional notion like 'apocalypse' suddenly reveals. A current prophet of doom like Lyotard, spokesman of the post-modern condition, who preaches in his book *L'Inhumain* (The Inhuman), that we live in the 'post-solar age', that is, that in 4.5 billion years the sun will go out and that therefore we must take heed now and prepare ourselves for that day, grants us not a mere millennium but 4.5 billion years in which to enjoy learning how to project humanity into a bodiless state![10] The cosmologist Stephen Hawking in 'The Future of the Universe', is still more generous, granting the sun around five billion years (in *A Brief History of Time* he threw in an extra 'or so' – 'five billion years or so'[11]), and the universe around 10 billion years, before the expansion of the Big Bang contracts into the Big Crunch.[12]

In *Zusammenstoss, Collision*, a brilliant post-Dadaist multimedia science-fiction performance text, Kurt Schwitters represented the scientific prophets of our age predicting a collision of worlds and an astronomical apocalypse, to take place when the Earth and a hitherto unknown planet, the 'Green Globe', intersect in orbit. *Tout Berlin* is in a tizzy, and the play culminates in a scene in which all the city's inhabitants rush to the airport, Tempelhof, where, it has been predicted, the impact will be most directly felt. The displacement from the sacred to the secular is explicit, for the event while lamented and prayed over in the cathedral is to take place at the airport, and the inhabitants of the great modern capital city crave more than anything to be 'in on' the most exciting news story of the day. The stage direction reads: 'Unendlicher freier Platz, unübersehbare Menschenmenge' ('Infinitely open square, countless masses of People').[13] The vast crowd and the riot police grapple with one another, swaying back and forth, and the vast shadow of the 'Green Globe' darkens the stage. In the event, the green planet is sighted but the collision does not take place. The scientist-prophets who have caused the panic by predicting the end that does not come, now come forward to take credit for its aversion, and are awarded the Nobel Prize. The avoidance of closure turns the apocalypse into social comedy, and a carnival celebration breaks out on stage.

Schwitters' post-Dada epic theatre or 'Opera in ten scenes' was written in 1927, but was performed only after his reputation as *Merz*-painter (painter of detritus, 'trash', found objects in a commercial society) was made and he was seen as an early practitioner of 'The Happening' of the sixties. The piece was first successfully mounted in Tubingen in 1976.[14] Recently it was taken up by the Dutch theatre company Orkater and staged in Amsterdam and Zurich as *Panic in Berlin*.[15] *Collision* has still to make a long overdue appearance on the English-language stage.

Both literary and scientific post-modernism are characterised by the po-faced ironies of postponement. A variant on the end-of-the-world scenario is the modern evolutionary theme, 'How long will the human race last?' Another splendid example of contemporary prediction of the future employs a new kind of scientific 'numerology' to explore this. J Richard Gott III, an astrophysicist at Princeton, has published his reckonings of when the species *homo sapiens* will die out in a recent issue of *Nature*, a leading scientific journal in which important new discoveries are reported.[16] Gott's article is entitled 'Implications of the Copernican Principle for our Future Prospects', under the section 'Hypothesis'. It is billed on the cover with the tag 'How long will our species survive?' – Nature's nearest thing to a 'scare headline'.

The Copernican principle enunciated in Gott's title is simply that 'we do not occupy a privileged position in the universe' – by extension (according to this argument), as observers we are unlikely to be present at the beginning or end. Even under the anthropic Copernican principle, which does recognise a limited form of privilege for the human race, we are privileged only to

the extent that we are 'intelligent' observers, not by being especially 'well-placed' observers.

Mankind, according to Gott's calculations, will die out in all probability at some point between (at the earliest) 5,128 years hence, and (at the latest) 7.8 million years hence. (Incidentally, by the same method he has predicted that manned space travel will be with us at the least in 10 months, or at the most in 1,250 years, and that the Catholic Church will last another 12.26 years or at the most 18,642 years.) The probability that this is the case is 95 per cent.

How does he arrive at this? The basic idea is simple. Whatever we know or do not know about a phenomenon, we can be quite sure that it is neither just at its beginning nor just at its end. There is only a five percent probability that it is in the first or last fortieth of its existence.

Gott's Postulate is: $1/39 \ t_{past} < t_{future} < 39 \ t_{past}$ for $P=0.95$.

If one knows how long something has already existed (t past), then one can calculate effortlessly how long it will continue to exist (t future).

This is much more amusing in German (I first found it mentioned on the front page of the 'Modernes Leben' section of *Die Zeit* for 2 July 1993) because of the play on the name of the author of this egregious theory.[17] In German his name is heaven-sent for the humourist: Gott= God. The article is entitled 'Gotts Formel' – God's Formula – and of course his postulate is God's Postulate. This rule-of-thumb as expressed in German is also more appropriate to our interests: for 'rule of thumb' is, of course, *Faustregel*. The rule-of-thumb is thus translated into the encounter of the human principle (Dr Faustus) with the superhuman or demonic. Thus we can calculate how long the great works of the canon will endure.

The delta t argument is just that t_{now} will be located randomly between t_{begin} and t_{end}. (Delta t signifies a small time change.)

The human species is $t_p = 200,000$ years old. The average longevity of a species is 1-11 million years; for mammals, average longevity is 2 million years. Our direct ancestor *homo erectus* lasted only about 1.4 million years, Neanderthal man still less.

The future lifetime of the species is calculated as follows:

$$5,100 \text{ years} < t_r < 7.8 \times 10^6 \ (95 \text{ per cent confidence limits})$$

The notion of 'confidence limits' is a very familiar one, not peculiar to Gott; and 95 per cent is the most common confidence limit. Thus by this mode of calculation the total longevity of our species= 0.205 million years to eight million years.

Gott makes some interesting further calculations based on the relation between population

growth and decline, and the extinction of species. An exponential growth (such as the human species is now undergoing) occurs before either (a) extinction or (b) collapse of growth to sustainable levels. Two possible models of 'sustainable' growth exist: back to a small, primitive community; or back to a sustainable level of about 200 billion for another four million years.

This is followed by a discussion of whether the transplantation of the species to other planets can occur. Gott concludes that it will not, on the grounds that species never realise their full potentialities. How can he know that this particular possibility will not be fulfilled? If Lyotard's exhortations have their effect, 'post-modern' man will in 4.5 billion years become 'post-solar' man. Gott's calculations, however, remind us that the species *homo sapiens* has a far shorter writ than the sun, and that our exodus into incorporeality looms in more ways than one.

That Gott's formula can be used with equal facility on a portentous event or on a perfectly trifling one is highly typical of a certain macabre scientific 'cheerfulness'. This is related to its required lack of affect: no emotional response is attached to even the most dire events; and the lack of proportion creates an effect of wit. The very distinction between 'portentous' and 'trifling' is thus questioned. Swift's *A Modest Proposal* called satirical attention to this effect of scientific equanimity.

For the humanist observer – indeed, for the common man – these 'predictions' are thoroughly discomforting and, worse still, uninformative. The grotesque humour of Pynchon's *Gravity's Rainbow* is achieved by bringing statistical prediction into direct relation with the pattern of an individual life. Schwitters made gleeful use of the fact that the degree of accuracy with which the scientists predicted the danger from the oncoming 'Green Globe' was sufficient to gain them a Nobel Prize, although the difference between their predictions and the actual outcome could be reckoned in the loss of (at the very least) thousands of individual lives. To the humanist observer there is a baffling range in the predictions of Gott's formula, just because the scale of delta **t** may itself be greater than the span of his own life, and in the case of astrophysical calculations beyond the span of the species. To commonsense the result of the calculation is a grossly unusable figure that offends against human perceptions of accuracy. Even where one of the dates is in individual human terms near, the distance of the other cancels its applicability and makes it an empty threat (or promise). A writer like JG Ballard materialises the dire probability at a near point (some thirty years from 'now') in his uncanny 'Myths of the Near Future', thus implicitly calling in question the factuality of prediction.[18] The humanist observer (even the *Die Zeit* writer) defends himself by turning such predictive methods into a satire on scientific futility. But science also levels an implicit satire at the human scale itself. Much Post-Modernist writing brings these disproportionate scales into collision, baffling expectation, producing unease. It has been said that 'Science fiction is as a genre potentially and even intrinsically

oriented toward humanity's furthest horizons';[19] what we find in Post-Modernism is the importation of the incommensurability of scientific and humanistic timeframes into the process of fiction itself. The 'cognitive shudder' is experienced as acosmic yet world-making playfulness. In Harold Pinter's new play *Moonlight* a life beyond death is effectively conjured up, simply on the basis that life as we experience it (in a Beckett or a Pinter play) is no less incomprehensible than death. The party begins at 'moondown'.[20] In October 1993, it may, like Zamyatin's zeppelins in the black-and-white light-pierced London sky of 1917, be turned into an image of deferred apocalypse.

Paper given at the Symposium on Post-Modernism and National Cultures at the Tretyakov Gallery, Moscow, 20-22 Oct. 1993 on the occasion of the opening of an Exhibition of Post-Modern Painting.

NOTES

1 Yevgeny Zamyatin, *Islanders* and *The Fisher of Men*, first published in Russia in 1918, translated by Sophie Fuller and Julian Sacchi, Fontana Paperbacks, London, 1985, pp89-90.

2 *Ibid*, pp94-95.

3 Pynchon almost certainly knew Zamyatin's work, including his novel *We* (1920), often linked with Huxley's *Brave New World* and Orwell's *Nineteen Eighty Four* as one of the leading dystopian works of the century, and never published in Russia. The title 'Entropy' of Pynchon's early story is also a link with Zamyatin, who set revolutionary and heretical energy against a nerveless entropy.

4 Norman Cohn, *The Pursuit of the Millennium*, 1957, Paladin Books, London, 1970, pp30-35.

5 Christopher Nash, *World Postmodern Fiction: A Guide*, Longman Group UK, 1993, first published as *World Games: The Tradition of Anti-Realist Revolt*, 1987, p117.

6 Jean-François Lyotard, *The Postmodern Condition: A Report on Knowledge*, 1979, trans Geoff Bennington and Brian Massumi, Manchester University Press, 1984, pxxiv.

7 Eric S Rabkin, 'Introduction: Why Destroy the World?', *The End of the World*, eds Rabkin, Martin H Greenberg, Joseph D Olander, Southern Illinois University Press: Carbondale and Edwardsville, 1983, pix.

8 Robert Galbreath, 'Ambiguous Apocalypses', in Rabkin, ed, *op cit*, p61.

9 Darko Suvin uses the image 'anticipating the sunburst' or new dawn, taken from William Morris' *News from Nowhere*, as typifying the Utopian genre of nineteenth-century science fiction, *Metamorphoses of Science Fiction*, Yale University Press, New Haven and London, 1979, pp170-204. See also Richard Stites, typifying the Utopian genre of nineteenth-century science fiction. *Metamorphoses of Science Fiction*, Yale University Press, New Haven and London, 1979, pp170-204. See also Richard Stites, 'Utopia in Time: Futurology and Science Fiction', chapter 8 in *Utopian Vision and Experimental Life in*

the *Russian Revolution*, Oxford University Press, 1909, pp171-173.

10 Jean-François Lyotard, *L'Inhumain: Causeries sur le temps*, Editions Galilee, 1900, *The Inhuman, Reflections on Time*, translated by Geoffrey Bennington and Rachel Bowlby, Stanford University Press, Stanford, California, 1991, pp12-14 and p64, where he speaks of 'exodus'.

11 Stephen Hawking, *A Brief History of Time*, Bantam Press, London and New York, 1988, p83.

12 Stephen Hawking, 'The Future of the Universe', in *Predicting the Future*, eds Leo Howe and Alan Wain, Darwin College Lectures 1991, Cambridge University Press, 1993, pp8-23.

13 Kurt Schwitters, *Das literarische Werk, IV*, ed Friedhelm Lach, Du Mont Schauberg, Cologne, 1973-81, p74.

14 ES Shaffer, 'The Intermedial Event: From Dada-Abend to Merz Theater', a lecture given at the joint meeting of the Dutch Comparative Literature Association and the British Comparative Literature Association, Amsterdam, 16 December 1988; for the links of his literary works with his painting, see ES Shaffer, 'Kurt Schwitters, 'Merzkunstler: art and word-art', *Word & Image*, vol 6, No 1 (Jan-March 1990), pp100-18.

15 'Panik in Berlin', *Orkater*, Amsterdam, 19 June to 3 July, 1985, reviewed in *züri-tip* (Zurich, 7 June 1985), p9. This production was incorrectly identified as the German-language premiere.

16 *Nature*, vol 363, No 6427 (27 May 1993), pp315-19.

17 Klemens Polatschek, 'Gotts Formel', *Die Zeit* ('Modernes Leben'), 2 July 1993.

18 JG Ballard, 'Myths of the Near Future', the title story of a book of his stories (Jonathan Cape, London, 1982), but applying to a sub-genre found throughout his works. For a discussion of 'factfictions' based on the assumption of the verity of a hypothetical event within the parameters of the possible as currently understood by science, see ES Shaffer, 'Significant Fictions in Recent Literary Theory', paper given at the Vth Literary Theory Colloquium of the International Comparative Literature Association held at the University of Madeira, 1-4 June 1992, published in *Dedalus: Revista Portuguesa de Literatura Comparada* [*Portuguese Journal of Comparative Literature*], ed MA Seixo, No 2, December, 1992.

19 Suvin, *Metamorphoses of Science Fiction*, p170.

20 Harold Pinter, *Moonlight*, Methuen, London, 1993.

LISA APPIGNANESI
POST-MODERNISM AND NATIONAL CULTURES

Setting off to deliver a paper on Post-Modernism to an unknown public in an adamantly free-market Moscow, some two weeks after the Russian White House had blazed and people had lost their lives in what was variously called a 'coup' or a 'third revolution', struck me as something of an absurdist challenge. What could one possibly say that bore any relation to what had just been experienced? In the event, I thought that an oblique approach which humorously (I hope) suggested how out of step East and West might be in the inflections given to Post-Modernist terminology might suit the circumstance.

The last time I was in Moscow was in December 1988, when I was putting together a Russian season under the title of *Novostroika* for the Institute of Contemporary Arts in London. So much history has taken place in the few years since then, too much of it perhaps in the last few weeks, that it does feel like something of a miracle to be here again – a double miracle, since this time round the body responsible for my journey is in Moscow, not London, and this open-ended and public dialogue is at the behest of a Russian, not Western, institution. Five years ago it would have been unthinkable for a museum like the Tretyakov to hold an exhibition and conference under the provocative rubric of 'Post-Modernism and National Cultures'. That this is now the case is a measure of the miraculous distance crossed.

However, miracles have less place in the post-modern discourse, than the dialogue across differences, and what I would like to focus upon in this brief intervention is a few of the ironies the post-modern condition has thrust upon us as East and West mirror each other; particularly the ironies Post-Modernist thinking, literature and art have given rise to since the term came into common usage some fifteen or more years ago.

I was alerted to a central one of these a few days ago when I awoke to hear Toni Morrison's voice on the radio. She had, of course, just been awarded the Nobel prize for Literature – and deservedly so, for she is a brilliant writer. In accepting the prize, Morrison said, 'What is most wonderful for me personally is to know that the prize at last has been awarded to an African-American'. She went on to say, 'I thank God that my mother is alive to see this day', adding, 'I am unendurably happy'. It came to me as I listened to the report on Toni Morrison's work (in French, since I am living in Paris this year), that it would never have occurred to James Joyce to say, 'What is most wonderful to me is that the Nobel prize has at last been awarded to an Irish writer', and Joyce spent at least as much of his time writing about Ireland as Toni Morrison has

about America, and as critically. Nor can I imagine Saul Bellow – to bring things nearer to date, though still a generation apart – saying how wonderful it was that a Jewish-American had at last received the prize. Nor would either of them then, I imagine, have mentioned mother (although Joyce's work is as entangled in mother as Morrison's), only at last to focus on the 'I' of the artist.

The difference between these two writers and Toni Morrison is, I think, the difference of Post-Modernism. Morrison situates herself at least in part, as the voice of African-America: she takes on a representative function not only in her art, but in herself as a person. She situates herself first as an African American, then as a woman – a daughter of a mother – and only thirdly as that other self, the writer. It is not too difficult to see that James Joyce and Saul Bellow's work is as grounded in their respective regionalisms (to use the word that predated the culture of ethnic identities) as Toni Morrison's; and indeed as marked by their gender. Nonetheless, where they would imagine their art as at least aspiring to a universality and representing, if anything at all, only their own artistic vision, Toni Morrison is in the first instance an African-American artist.

I mention Toni Morrison because her name has recently been in the news, but this notion of the artist as representative of a group identity – be it feminist, gay, native or any other American, or Quebecois, or Welsh, is a current one – as the 1993 Whitney Biennial made plainly evident. The irony of this is that the only other contemporary place and time in this century where artists would situate themselves and be situated by their public – critics and apparatchiks of whatever status – as representatives, was in the Soviet bloc, at a time when the grand revolutionary narrative was still more or less in place. Hence, Gorky, for instance, could in some sense see himself as the representative of the revolutionary proletariat.

One of the commonplaces of Post-Modernism, first diagnosed by Jean-François Lyotard in his *La Condition Postmoderne* of 1979, is of course of the notion that the consensual, grand – or if you like the master – narratives of modernity, such as the dialectic of Spirit, the emancipation of the worker, the taming of nature, the accumulation of wealth, the classless society (all of which have progress at their core) have lost their credibility. Post-Modernism is, in that sense, a crisis of cultural authority, specifically perhaps European authority.

In place of our grand narratives, the common notion goes, we have any number of weaker narratives, narratives which do not imperialistically shout their centrality, narratives which may sometimes melancholically mourn the past, but nonetheless narratives which recognise that they are simply one amongst many stories of equal value in a pluralistic world.

In the English speaking world, particularly in America, this has manifested itself in attacks on the so-called Eurocentric university curriculum, on DWEM's (Dead – or Dying – White English Males) and, more crucially, in the growth of a multi-culturalist model of civic life – a stew in which all differing ethnic pieces are left intact – rather than on the older melting pot notion

which assumed that all differing flavours and ethnic ingredients would be merged into a smoothly American, succulent, soup. However, to posit and to begin to live as if all cultures are equal, to live with plurality, is not an easy process, as recent history has all too clearly shown.

In 1962, the French philosopher, Paul Ricoeur wrote: 'When we discover that there are several cultures instead of just one . . . when we acknowledge the end of a sort of cultural monopoly, be it illusory or real, we are threatened with the destruction of our own discovery. Suddenly it becomes possible that there are others, that we ourselves are an 'other' amongst others. All meaning and every goal disappear . . . '

To be simply an other, any old other amongst others, is not something anyone, let alone the artist, can accommodate him or herself to without difficulty. For hundreds of years, the West emphasised the artist's singularity, his genius, his exceptionality, or at least the aspiration to the authenticity of voice or form. Now, we have not only philosophies which dismantle the self, but also proclaim the death of the author/artist and the central importance of a system of signs above and beyond any traces the individual may leave on that system.

In tandem, the artist becomes more and more suspicious of being an Artist with a capital A, since this is one more illusion produced by a sign system. From whence then is the authority to take pen to paper or brush to canvas to come?

Increasingly, it seems to me, artists in the West have taken refuge in a representative function. It is an interesting strategy. The represented group, in a sense, shores up the embattled artist, and permits him or her to give up arrogance and individualism – both of which are recognised as illusions – while at the same time maintaining strength.

A representative is, as we know, speaking in the voice of another (it makes a lot of difference, of course, to your theory of representativity whether you are speaking in the voice of another or on behalf, or in the name of another – as your recent historic event has made clear – but we will not go into that here). A representative is himself or herself an absence, in which authority is vested from without. In the name of the other – be it the disabled, the otherwise sexed, the black or Native or Asian American, or perhaps equally (though I am not certain of this) the American or Moldavian – the representative artist can be strong, even sometimes strident and proclaim the centrality of the injustice done to the group.

This is the point where the second irony comes into focus. For the groups that are most often represented in this way are the groups whom, it is felt, have in one way or another suffered a historic injustice. It is as if the West, in particular the Anglo-American West, has inherited one of the splinters of Marxism. Not perhaps the Big Totalising Marxism of history on horseback, but the local and parochial one, which seeks to give the oppressed a voice, to champion their case, to render them visible, to give them identity, to affirm the legitimacy of the class or group – in a

word to re-present them. Just as an aside, it is interesting to note, too, that the main philosophical discourse of Post-Modernism, which is deconstruction – a discourse which is inherently sceptical and which might seem on its surface to posit an equivalence between differences in the way in which it is most often applied – seems to carry within itself a repressed or hidden ethic of collective rights. Narratives are not simply equal and different. Some deserve more rights than others.

In a sense, what I have been talking about so far could be characterised as a marxist (with a small and Western m) aspect of Post-Modernism. I would like to take a moment – since we still live in a world where the legacy of those differences leaves its trace – to mention an experience of what could be called capitalist Post-Modernism.

One of the first things I was called upon to do by my daughter when we arrived in Paris was to make a coveted visit to EuroDisney. I only resisted a little, for I must admit I was curious. For months our media had been filled with the advent of Disney to France. French intellectuals who had taken positions on this newest form of American colonisation, complete with French collaboration, had declaimed it a 'cultural Chernobyl'. Travel agents had announced a thousand package deals to this newest glittering star in an already wondrous Paris firmament. Financial pages had droned on about risks and shares and investments and subsidies.

The metro took us there in style – together with hordes of Italians, English and Spanish – and released us into what I can only describe as the apogee of a world become pastiche – a world wearing a variety of stylistic masks, unleavened by any particular humour. Talk of post-modern eclecticism: a Victorian gothic manor some hundred metres away from New York Art Deco, next to New England seaside retreats in best Kennedy style, next to rustic chalets in pared down frontierland mode. And these are only the hotels.

The theme park itself is entered through Main Street, USA – a sanitised version of an American high street c1900s, complete with trams and themed restaurants and too many shops selling Disney souvenirs – all but empty on the day I went.

Of course there are the different lands as well: Frontierland with its French-speaking Indians, stuffed cowboys, giant riverboat, scaled-down Grand Canyon and wax buffalo; Adventureland with its pirate boat-ride which mimics the taking of a Caribbean port; Fantasyland with its Alice in Wonderland mazes, Ludwig the Second castle, Peter Pans and Pinocchios; and finally, Discoveryland, the marvels of the future subsidised by hi-tech firms: Michael Jackson in 3D as a Star Wars Captain Eo transforming the hideous enemy monster through music into a dancing Hollywood Cher.

What became clear to me in the course of the day was that the adults (whatever their national origin), including myself, were enjoying the EuroDisney experience far more than their children.

These European children on the whole seemed disgruntled, racing from one marvel to the next with apparently growing dissatisfaction. It was as if for them, the appetites, the desire whetted for the Disney experience by the barrage of prior (usually filmic) advertising could not be fulfilled by the 'real' thing. A man in a Donald or Mickey suit, a tableau of Snow White, even a ride on the Big Thunder Mountain roller coaster through Frontierland, were nothing compared to the far richer (and perhaps realer) experience of a good movie. You will catch me out on the post-modern confusion of terms here: we are into 3D simulacra after all; the bodily mimicking of the two dimensional fantasy purporting to be a representation of, well, just what? Jungian versions of the unconscious, perhaps? History?

Anyhow, the children were disappointed. The adults, however, were – when not too distracted by their ever-desiring children – in a state of relative bliss. Me too. Why? I suspect the answer lies in nostalgia. For us Western Europeans in any event, Disneyland is childhood. We grew up with the German Brothers Grimm transmuted into sentimental Disney characters; with an English Alice in Wonderland remade by the Disney magicians, with Ludwig the Second's castle as the backdrop for the Disney theme song, 'When You Wish Upon a Star', with a Frontierland where the battle between good and evil was eternally replayed by cowboys not yet dying of Marlboro cancer, and Indians who had not yet become Native Americans. So to be in Disneyland – in certain respects always a EuroDisney since Walt Disney had long ago plundered the European myths – for us grown-ups was to bask in childhood and relive its aesthetic artefacts or its kitsch once again.

This condition of nostalgia for a historical time which was in itself out of history, is another aspect of the post-modern condition. Under the trope of memory, always in part an invented past, theme parks have proliferated – whether to give one an England that never was or an America that would have liked to have been or perhaps – though here I must tread delicately along the tightrope of political correctness – an experience of native roots.

In closing, I should mention that EuroDisney is foundering, not because of the railing of intellectuals about its constructions made of 'solidified chewing-gum and its idiotic folklore'. Apart from the structure of the initial investment package, the children simply have not liked it enough to keep their parents in those post-modern hotels long enough to part with sufficient cash. Then too, there have been staffing problems. The Europeans do not seem to be as amenable as their American counterparts to smiling the Disney smile and wishing everybody a sanitised good day.

One can only say, ' Vive la Différence' (though perhaps these grim days the emphasis should be on the 'vive').

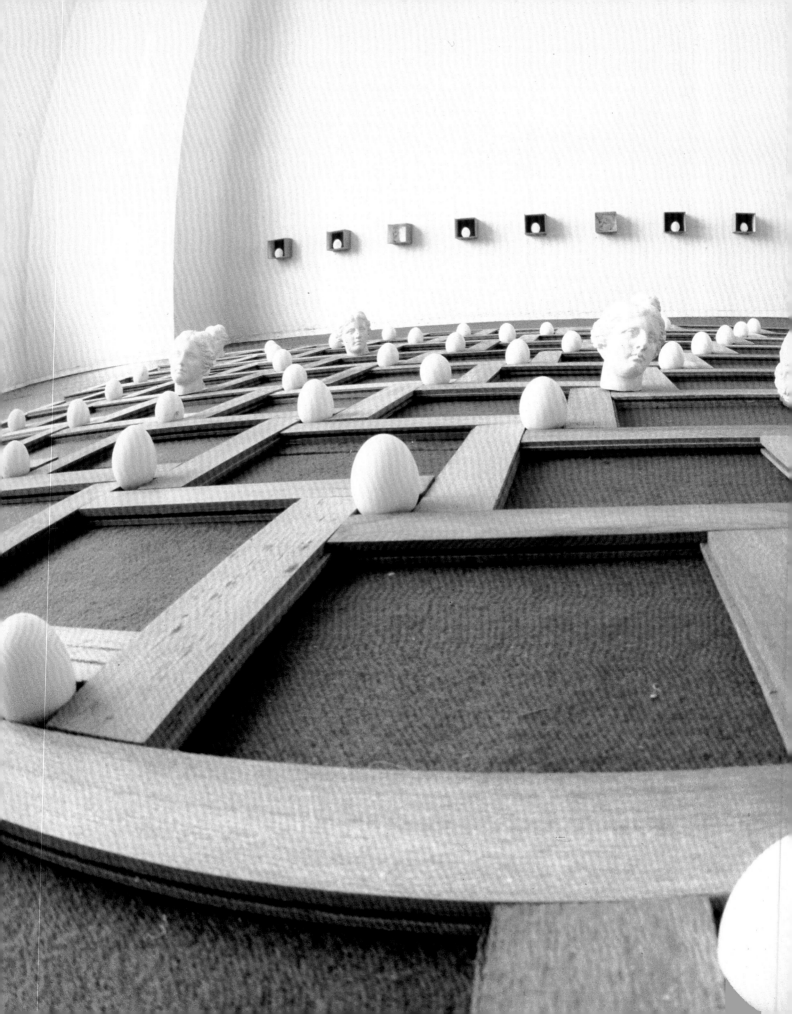

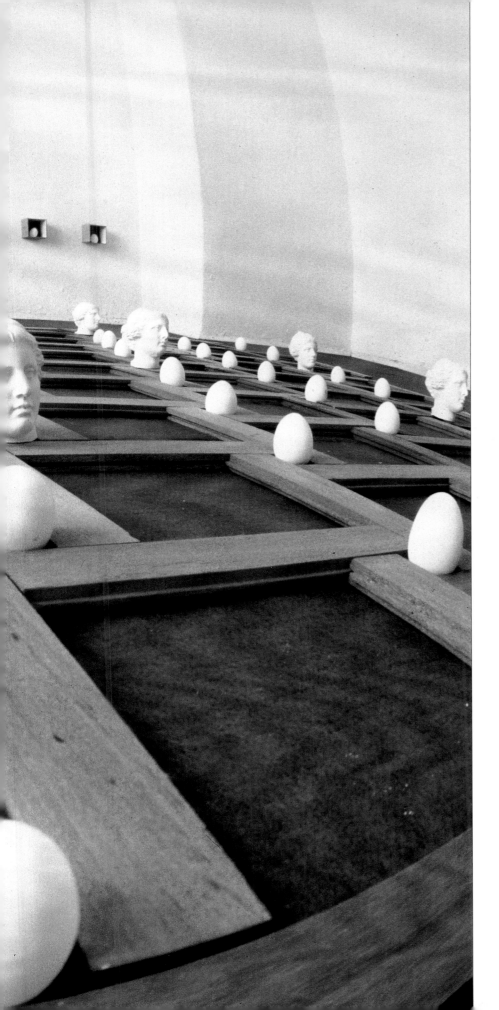

THE
IMMOVABLE
FEAST

NADEZHDA YURASOVSKAYA

THE IMMOVABLE FEAST
A Story of Soviet/Post-Soviet Post-Modernism

'The individuality of things or of beings escapes us . . . we confine ourselves to reading the labels affixed to them . . . '

Henri Bergson, *Laughter.*

'The set of objects the museum displays is sustained only by the fiction that they somehow constitute a coherent representative universe. The fiction is that a repeated metonymic displacement of fragment for totality, object for label, series of objects for series of labels, can still produce a representation which is somehow adequate to a non-linguistic universe . . . Should the fiction disappear, there is nothing left of the museum but 'bric-a-brac', a heap of meaningless and valueless fragments of objects . . . '

Euginio Donato, *The Museum's Furnace: Notes toward a Con-textual Reading of Bouvard and Pecuchet.*

In October 1993, the Tretyakov Gallery displayed the exhibition 'and Post-Modernism and National Cultures: Art of the USSR from the 1960s to the 1980s'. The provocative undertones implicit in the very name of the exhibition were deliberate. Despite the omnipresence of the idea of internationalism in Soviet art, any strict adherence to the Western concept of Post-Modernism, be it a continental or an American version of it, would reveal a lot of contradictions. Nevertheless, such a formulation of the problem could, on the one hand, reflect the traditionally dualistic character of local consciousness, while on the other it could emphasise in advance the paradoxical essence of Soviet art at the phase of its eclipse. What is more, the organisers aimed at raising – through the means of such an exposition – some questions of extraordinary acuteness for contemporary artistic life, such as the relation between artistic processes here and in the West, the role of national cultures in the modern world, the adequacy of theoretic constructions in culturology and of artistic realities of contemporary art.

The exhibits reflected an attempt at tracing the trajectories of those natural developments in fine arts which, at the final analysis, have exerted significant influence on the splitting of the totalitarian state system and have eased the search for the once-lost ways to the Promised Land of world civilisation.

As early as the 1940s, Arnold Toynbee expressed concern for the progressive decay of the Modernist era; the era that he, and Spengler before him, saw as a movement which began with the Renaissance and led to internationalism, the rise of the proletariat and the merger of 'non-Western cultures' with the general world process.[1] The advent of the post-modern epoch was seen by some analysts as a stage in the new consolidation of fragmented society (resorting, say, to a new myth), while others expressed hope for the advantages of active pluralisation and fragmentation.[2]

While prior to the mid-1980s the quest for new principles of artistic

Ieva Iltnere, *The Rope Dancer*, 1988, oil on canvas (Latvian artistic school)

work had had a latent character here, Gorbachev's *perestroika* became the historic chance for Promethean ideas, clandestinely formed on the periphery to begin their march to the foreground.

Beginning in the late fifties, reality intertwined new fronds into the canonical structure of Soviet society. For the fine arts it was not limited to the Underground movement alone. Oriented both to the native Modernism of the eve of the century and to contemporary trends coming from the West, it could have emerged only in urban centres. Here the lack of information was less pronounced. The 'special collections' of libraries, second-hand book shops, museum store-rooms housing the officially prohibited works of avant-garde artists from the early 1900s; the 'catacomb' circles and exhibitions in shared apartments, certainly created an environment typical of contemporary consciousness, so avid for various 'graftings', 'roll-calls' and 'traces', but only, or predominantly, in Moscow, Leningrad, Tallinn, Riga and Vilnius . . .

The decades-long ban on analysis and any attempts at dissecting the sacramental symbol of political reality resulted in the fact that for the consciousness existing within Soviet culture, the essence and its representation in the word, image or symbol became inseparable. Meanwhile, the strategy of Post-Modernism targeted at non-disproving, non-incantating, non-repudiating irreversibly but on the contrary impassionately accepting all ideological clichés proved itself to be – as we see it – sufficiently effective. A certain caution in choosing such an approach to the study of local material is caused by the recently predominant views on the phenomenon of Post-Modernism as the 'cultural logic of late capitalism'.[3] But will not this logic be the Procrustean bed as soon as the discussion turns to the art of post-industrial Japan? And will the maxim of Michael Epstein: 'The Soviet Union is the fatherland of Post-Modernism',[4] sound that arrogant in this context?

The second half of the this century brought a feeling of crisis in art to both the USSR and the West. The influence of Communist ideology, once the guarantor of stability of the social order in the Soviet Union, was increasingly losing its strength after the death of Stalin. Beginning with Khrushchev's 'thaw', this process was to a large extent accommodated by the emergence of a political movement for human rights, appealing to the internationally accepted legal norms. On the other hand, nationalistic sentiments were on the rise in the Union republics, which was only natural in the conditions of decay in which the regime found itself.

The ideological vacuum in Soviet society resulting from a deep disillusionment in the vitality of the Soviet model based on the principles of class struggle and dialectics, stimulated the quest for some new nostrums to support the dying system. This took the form of either the wish to restore bygone might, to update the regime (the idea of the Marxist Left) or to replace it gradually by the Western system of self-regulation (after Parson).[5] In any case, the real comprehension of the collapse of the Communist idea, so 'nutritious' in the past for the conscience of the peoples who inhabited one-sixth of the globe (not counting the oceans), a fact so eagerly emphasised by the late leaders of the Soviet Union, filled people's minds with eschatological misgivings and moods.

Though the pompous all-Union art exhibitions organised in Moscow once every four years were intended as usual to demonstrate the continuous movement of society to the summits of Communism, the

Edward Gorokhovsky, *Twin Portrait in a Box*, 1991, oil on canvas, wood

exhaustion of this idea became clear to the artists. The fulfilment of the 'order' on a purely emotional level could be achieved no more. To no avail was even the national-patriotic pathos which introduced a spirit of enthusiasm into pictures painted in the 1930s. Now the most candid feeling was replaced by aloofness or by the instinct of revivalism or servilism. Thus came the overtone of parody which typified not only the ceremonial genre of that time but also permeated the whole of life in the USSR. It is not pure chance that the favourite genre in folklore of the 'period of decay' was the political joke, the gist of which sometimes remained mysterious to foreigners.

The gap between the official line and the artistic personality's real position in the Brezhnev era could have been bridged by irony alone, sometimes disguised, sometimes direct (as in the case of Sots art). Born of the absurdity of Soviet pseudo-life, which related to every detail of existence from foreign policy, scientific research and nuclear weapons to the least significant nuances of housekeeping with its utility from the point of view of the regime, the joke proved to be an excellent means of revealing the concealed essence of a work of art, its 'other' sense, the means produced by the native environment which had developed in the country. 'Post-culture',[6] 'Post-traditionalism',[7] 'Post-catastrophe'[8] art are just a few of the terms engendered in the 1980s on the pages of the still-Soviet periodicals such as *Kunst* (Estonia), *Art* (Russia), *Rodnik* and *Daugava* (Latvia).

One should not omit the fact that the new problematics heralded by specialised journals, as well as new lexics and terminology, to a certain extent echoed the debates on Post-Modernism that were deafening Europe and the lands beyond the Atlantic. On the other hand, the custom of considering the situation in this country in isolation survived until the lamentable end of the USSR (and, alas, is very much alive even today).

Seemingly, the Iron Curtain should have reliably preserved the virginity of Soviet culture from any allurements of post-industrial society of consumption fertile enough to produce a new form of artistic conscience. Nevertheless, it is hardly incidental that the artistic search in the West and in the Soviet realm followed similar lines.

The aesthetics of Socialist Realism superimposed here since the 1930s by the ideology of the totalitarian state were inspired by the academic tradition of the nineteenth century, and yet strategically emulated Modernism with their claims to transfiguration of the world, monopoly and universalism.

Renato Poggioli in *The Theory of the Avant-Garde* justifiably states that 'in Russia, language fears neither barbarisms nor neologisms and, from the beginning of the epoch in which avant-garde art became a primary and universally important phenomenon, down to our own day (to the nationalist turning-point of the Revolution), Russian culture has sympathetically welcomed exoticism of any sort. Original form and concept penetrated easily and quickly. But the pronounced tendency of the Russian critical spirit to translate artistic and cultural facts into religious or political myths has impeded any valid formulation of the concept . . . The one current in Russian criticism which was obliged to give sustained and careful attention (however ill-disposed) to the concept of the avant-garde was the radical, sociological, or Marxist school. It did not, however, limit its study to the historical and social viewpoint (which would have been legitimate) but went beyond, to

George Kizelvatter, FROM ABOVE: *Blossom Still More Beautiful, Dear Motherland!*, mixed media; *O Tempora, O Mores!* (word-play on 'O Tempera, O Mare!'), oil on canvas

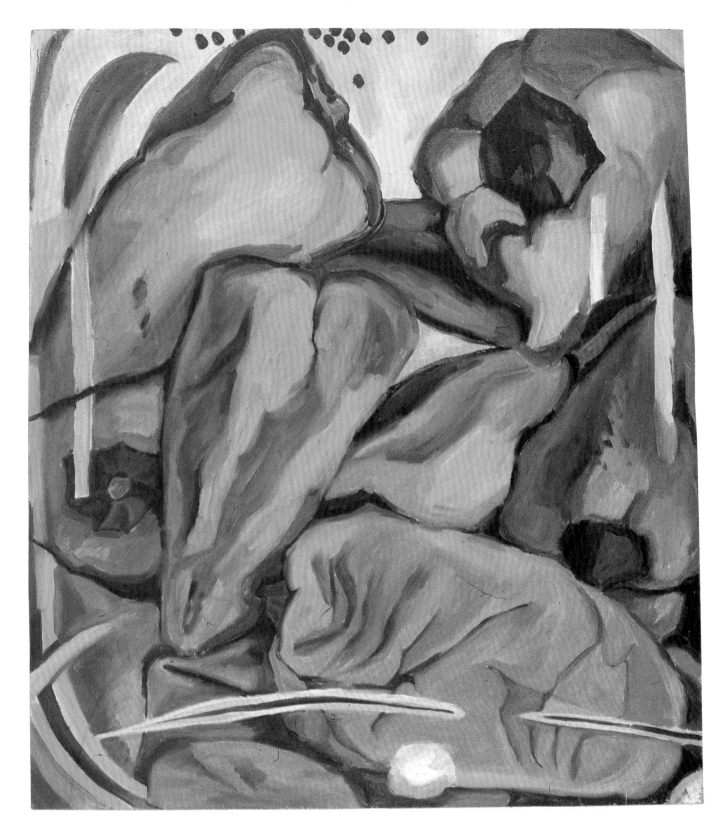

Nina Kotiol, *Aquarium* (one of four), 1992, oil
on canvas

confront it from the viewpoint of a pragmatic sociology, partisan and political, with a mania for therapy and reform'.[9]

Trying to substitute the universal picture of the world with a mere fraction of it, the model of Socialist Realism engulfed in nihilistic rage had reached its climax by the middle of the century. The climax was the so-called 'Applause style'. The applauding subjects of the state, elated by the happiness of life in the USSR, overcrowded canvases from the 1950s (produced by Ephanov, Antonov, Samokhvalov, Gerasimov, etc). They were nothing but simulators, begotten by the art of false representation which reflected no reality at all. Today, these grotesques are seen as anticipators of Post-Modernism,[10] or as a 'totally and undoubtedly victorious Modernism, an "accomplished" avant-gardism . . . Suffice it to mention the self-definitions of Socialist Realism as a style most progressive and advanced',[11] argues the critic Andrey Kovalev.

The penetration into new artistic and plastic space undertaken by the local counter-culture of the late 1950s to the early 1960s coincided with the cultural crisis in the West. Nevertheless, in contradistinction to French 'New Realism' or American Pop art, the point of departure here was specifically local.

The Soviet Underground, artistically and politically risqué, was clearly weaker in its artistic efficiency than contemporary Western art, owing to the inferior quality of local raw materials (from brushes and paints to scrap iron) with which the artist had to operate. But the works of Ilya Kabakov, Oleg Tselkov, Vladimir Nemukhin, Dmitry Plavinskii and others who overstepped the barrier between life and art, demonstrate a combination of intellectualism, authenticity and fantasy of expression that could have been attained only on the basis of personal courage, vitally important in the then repressive social situation. Irony approached sarcasm, thus revealing not just a formal attitude of the artist to his objects but also his world outlook as such.

By contrast with the Western strategy of inclusion of the classical code from past centuries into the new conceptual context, indigenous culture manifests the tendency for reanimation of the language of the Russian avant-garde of the early twentieth century. It is possible to distinguish at least three principal starting points for the search by intuition for 'the sympathies and links which exist between the exterior (concrete) scene and the interior (abstract) emotion':[12]

1 Abstract-Constructive art (Kasimir Malevich, Vasily
 Kandinsky, El Lissitsky);
2 Futuristic Objectivism (Vladimir Tatlin, Olga Rozanova);
3 Photo-collage (Alexander Rodchenko, Dziga Vertov)

The changes spread also to much wider, 'official' artistic circles. The officially authorised Picasso exhibition in Moscow in 1956, the first direct contact with a contemporary artist from the West, reminded the Russian audience of the great contribution made to the art of the twentieth century by Cubism and hence by its predecessor, Cézanne. The importance of his artistic method for the whole spectrum of modernity is reluctantly recognised even by artists of national-patriotic orientation such as Ilya Glazunov, though they are prepared to see Cézanne's method of organising the Universe into a set of geometric figures in some sort of genetic relation with the Marxist approach to society as a struggle between antagonistic classes. For them, Cubism equals Marxism, directly deriving from Marxist reductionism. 'It leads to

Evgeny Gorokhovsky, *Thin and Flat, It Whistled but did not Puncture*, 1990, oil on canvas, 180x240cm

Datse Liela, *Entrance*, 1988, oil on canvas,
150x200cm (Latvian artistic school)

FROM ABOVE: Sergey Shablavin, *Russia*, from the 'Circle in a Square' cycle, 1989, oil on canvas, 100x100cm; Sergey Shablavin, *The Unity (House)*, 1985, oil on canvas, diameter 84cm. The shadow letters read 'United'

a total ruining of civilisation with its spiritual values and to confrontation – this is why it is referred to as "leftist art". Sinners are, incidentally, summoned to attend the Last Judgement on the left-hand side',[13] says Glazunov, the perpetual self-styled 'frondeur', or something of the kind.

The much-heralded and seemingly omnipresent return to the starting points of Modernism was not nearly so absolute. The gesture of juxtaposition was completely lost, while the gradual reintroduction of the modernist code into the existing texture of art was becoming an end in itself. Totalitarianism in art was still alive, but artists, striving to get some breathing space in its fetters, were already trying to create a new and uniform style, a recombination of images/signs, for example, the 'Stern or Severe style'. Among these artists were the Latvians Edgar Iltener and Boris Berzinsh, the Azeri Tair Salakhov, Klychev from Central Asia and the Muscovites Pavel Nikonov, Viktor Popkov and Dmitry Zhilinskii.

Offered throughout a decade as a standard of artistic weights and measures at the All-Union exhibitions in Manege (a historic venue in the centre of Moscow), this trend disintegrated in conditions of weakening self-blockade. As if in contradiction to it, the republics gave birth to various groups of artists with their own programmes. By the end of the 1960s, tiny Estonia alone had several artistic associations: 'ANK-64', 'The Independents', 'The New Documentalism', the first in the country to react to the emergence in the United States of Photo-realism and Hyper-realism. Strategies of this kind were generalised and irreversible.

The dismantling of the system of values dominant in the totalitarian state depended equally, if not more, on the strengthening of the so-called national artistic schools. To prohibit the creation of these schools in a country which consisted of fifteen member-states inhabited by peoples of different religions and with different historical pasts was rather difficult; especially since this tendency did not contradict the principles of Socialist Realism, one of which affirms that Socialist Realist art is 'national in form and socialist in content'.

Each of the national schools situated on the cultural and geographic periphery of the empire was formed on the basis of the traditions of the corresponding people correlated with the ideological regulations in the spirit of 'internationalism'. The sphere of interest of the said schools included the semantics of Western (Eastern, Southern etc) cultural patterns which were felt to be nearest to the ethos which this or that school was eager to represent.

The reason for the cultivation of national traditions was strongly motivated by the recent agrarian past which had not yet become history. The age-old proximity to earth and nature, with respect to the idea of kinship and everything related to it, filled the ethnic consciousness of a whole sweep of peoples from the Slavs to the smaller groups like the Tadjiks. The acute feeling of good and evil, 'spirituality and cordiality' (the trademark of the Russian mentality) might well be rooted not only in adherence to the rules of the Orthodox Church, but in the main by the residual rural consciousness still resisting 'urbanisation' and its accompanying complexes.

Despite the official course of total industrialisation, and hence the urbanisation of society and the increasingly cosmopolitan aspect of culture, the echoes of nineteenth-century Slavophile assertions that art without national roots is doomed, found an ever-increasing audience in the national-patriotic Russian milieu. This way of thinking was easily

adapted in the republics as it was consistent with the rising movement for national liberation of the dependent territories. The only legitimate way to manifest the new spirit was through art and, first of all, fine art.

The introduction of a national code into the structure of contemporary stylistics, initially in the form of ethnic ornament, then by alluding to such things as national mythology, gave an opportunity for each republic to find its own specific way in the labyrinth of contemporary art. It cannot be denied that the inclusion of these nations in the context of Russian and then Soviet history influenced the course of their adaptation to the Western cultural world. It holds true both for young cultures such as Latvia and Estonia, supported by Russia in the nineteenth century (ironically, as presumably anti-German), and the ancient ones such as Armenia, Georgia and Uzbekistan, produced by the East. On the other hand, the Baltic states which were incorporated into the imperial system to a lesser extent, served as a conductor of information coming from the West, while Central Asia inevitably balanced the urbanistic orientation of the country by its deep belief in the strength of national roots.

Owing to a lack of personal modernist experience, entry into the epoch of Post-Modernism was rather difficult for any of the republics. Nevertheless, each of the national schools considered the Russian avant-garde of the early twentieth century to be its own. The crystallisation of traditions has come into effect. An indirect explanation of this phenomenon is offered by the writer Andrey Bitov: 'The Soviet regime has condensed time, has compressed it by repression to the tightness of the Egyptian ages, causing structural changes in the bedrock by the immense weight of the superstructure. We were so squeezed that what took centuries and millenniums to carry out, we have learnt to accomplish within two or three Five-Year Plans'.[14]

When the artist is mature enough to abandon the phase of exaltation with national culture as such, he or she nevertheless continues to consider him or herself a representative of a concrete people and its art. In order to partake of the feast of freedom and democracy, the demiurge of art is eager now to become oriented within the realm of contemporary culture using quotations as milestones. His attempts reflect the wish (but not necessarily the ability) to restore the disrupted links with the broad field of civilisation.

In getting rid of the inferiority complex and believing they are on a par with the rest of the world, the national schools are trying to construct their own vision of reality. However, it is strange that for decade after decade, the artists, be they from Tallinn or Kiev, Riga or Yerevan, have always followed the same method of structuring avant-garde situations in this or that combination of the same elements: the 'new concepts', 'installation', the environment, 'happenings', performances etc. The urge to single out some universally recognised centre disappears. At best, the interest in concrete phenomena would be dictated by national character or the individual artistic temperament of the artist. Thus, the emotional Lithuanian painters clearly prefer Neo-Expressionism; as reserved Northerners, Estonians are prone to Conceptualism or geometrics; artists from Armenia are evidently fascinated with photographism . . .

Access to an open world ruled by commerce where it is difficult to surprise anybody with anything has led to a certain amount of disillusionment. Especially vulnerable were the artists who still remembered the totalitarian edict 'not to challenge the hierarchy'. Sots art was luckier

Sergey Sherstiuk, *Sleeping Flora*, 1991, from the 'Flora' series, acrylic on canvas, 140x160cm (Zig-Zag Corporate Collection, New York)

– but as a grotesque form full of sarcasm, which could have emerged only in Russia: 'In the West, they [Komar and Melamid] would say repeatedly, there is an overproduction of things, of consumer goods. Pop art makes fun of this. But in the Soviet Union there are shortages of everything: of meat, clothes, apartments. There is overproduction only of ideology. Political slogans, painted large, are everywhere . . . Heroic portraits and sculptures of Lenin abound. Komar and Melamid would satirise this style'.[15]

This is just one example of how Sots art and its founding fathers were viewed in the West. Generally, the trend was accepted, and it was not the success of a Cinderella. The coup had been masterminded long in advance according to the rules adopted there. Emerging in the 1960s as 'underground' criticism of the Soviet regime (Igor Orlov's 1967 *Triumph of Socialism* was among the first signs of it), Sots art and the rest of the Underground had their zeniths and nadirs in Russia. In the seventies, riding on the wave of emigration (such as that of Komar and Melamid), it crossed the borders of the USSR. The eighties crowned with special attention on the part of the Western audience: interest in the changes of the Evil Empire was on the rise.

On becoming the best-known phenomenon of post Socialist Realist art, Sots art has been visualised as the only pattern of consciousness, poetics and style rejecting socialism, as a 'Soviet Post-Modernism'. But such an interpretation appears to be too 'localising'; it narrows the context of the phenomenon too much, and distorts the artists' intentions and the very essence of their work. For the area of 'proliferation' of local (Russian? Soviet? Post-Soviet?) Post-Modernism was that of world culture as a whole, though because of a number of reasons the Russian soil was not fertile enough for a discourse on the concept of Post-Modernism aimed at defining it as 'Anti-Modernism' or 'Trans-Modernism'.

All these considerations were borne in mind as a group of curators and art historians from Moscow's Tretyakov Gallery (Natalya Aleksandrova, Olga Yushkova, Natalya Rosenvasser, Lana Shikhzamanova, Nadezhda Yurasovskaya) worked on the exhibition on 'National Traditions and Post-Modernism'. Preparing an exhibition on such a scale was not an easy venture, due to the immensity of material which had either to prove or disavow the legitimacy of the legitimising discourse on Post-Modernism seen at such an angle. Equally immense is the variety of definitions of Post-Modernism and considerations pertaining to it, which often contradict each other. To list them here even without an attempt at comparative analysis would mean trespassing on territory thoroughly explored by a host of scholars.[16] From this motley assortment, the criterion coined by Charles Jencks sounds most appropriate in the artistic situation with which we are dealing: that is 'double-coding'. Jencks summarises his idea in the following way:

> The type of Post-Modernism I support, contrary to the deconstructive version, also embraces shared and "universal" values, as well as their antithesis. One can express this antipodal morality in many ways; I have continued here and elsewhere to use the phrase "double-coding" to indicate the opposition. The dual obligation towards the individual and group, part and whole, subculture and society has become a defining goal of Post-Modernists.[17]

Thus, the all-embracing Utopian model has been replaced by a multitude of try-outs and experiments typical of the contemporary art situation.

Aristarkh Chernyshev, *History of a Love*, 1992-93, diptych, mixed media

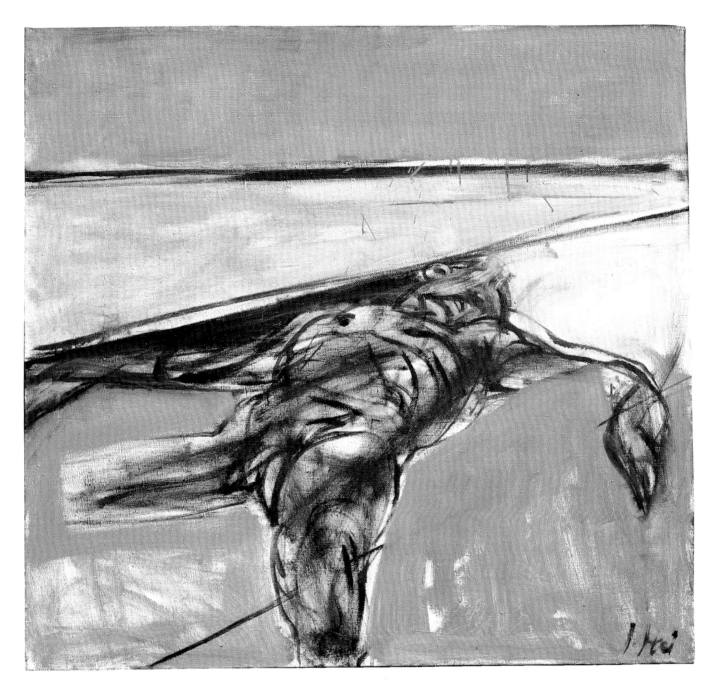

Ivars Heinrichson, *Nude*, 1991, oil on canvas

During his visit to Moscow in October 1993, Jencks said that his most vivid Post-Modernistic impression was undoubtedly the Russian Parliament building, the White House, partly burnt down during the attempted pro-Communist *putsch* and called afterwards the 'Black and White House'. For his part, Jencks called it 'the sign of the death of Modernism', seen by the world live on television, as vivid as the demolition of Pruitt-Igoe in St Louis in the United States. By using as an example the 'Black and White House', he illustrated his idea of differences between 'Traditionalism', 'Modernism' and 'Post-Modernism'. In the first case the building would be restored to its initial appearance; in the second it would be demolished; in the third, the lower part would remain white, symbolising the past, the top would remain black, symbolising the present, while the connection area would have been decorated with a frieze, symbolising the future.[18] The second two ideas went unheeded and Turkish workers have restored the perished lily-whiteness of the structure . . .

Meanwhile, the exhibition at the Tretyakov Gallery did not discover any new names; that was not its purpose. The material, well known by its audience, was shown without any obsessive aim of criticising or eulogising the accents and orienting points sacred to (post-) Soviet art-critics. As a result, works recently marked with a plus sign ('official') and with a minus sign (Underground or the 'other art') looked very organic in the general picture of the last phase of Soviet art (from a contemporary viewpoint of course). The historical image of Russia as the 'big brother' was also levelled out here, while the art of the regions revealed their cultural identity in everything but local – national and ethnic – features.

The core of the exhibition was the performance staged on the opening day by Andrey Bartenev and his group (music by A Shvarts, arranged by M Pekarskii, conductor R Gimatdinova). Called 'The Flower of the Snow Queen', it combined a series of objects from two previous performances by Bartenev, namely 'The Botanic Ballet' and 'The Snow Queen'. The 'happening' took place amidst symbols of the tundra – Icicles, the Tongue and the Eye. The performance artist describes the action as follows: 'The black-and-white objects organise the scene and space of the tundra for the advent of their future, the black-and-white Flower which will help them in reincarnations to come. Amid the crowd of Uncle Plum, the Kariak Thermoelectric Plant-1, the Submarine, the Violet Dressing-Gown, the Booth of Glasnost and five "A" girls appears the Flower . . . Everybody waltzes around it, showering over the Flower pink *puzhiks* [from the Russian *pugat* – to scare], and immediately transforming themselves into big plastic dolls. The black-and-white objects are joined by various others from the "Snow Queen" series – the Icicle, Kay and the Snow Queen, ceremoniously escorted by the Tsarevna Swan and the Tsarevna Frog. The snow (represented by shredded pages from illustrated magazines) starts to fall. The black-and-white objects disappear and only the bright plastic objects continue to waltz around the Flower. Another time has come. And with it has come another I'.[19]

In the environment of the Tretyakov Gallery, this performance could be interpreted as a sign of the Russian culture of the twentieth century compressed by history into a homogeneous entity, comprising everything from Art Moderne to Post-Modernism, from Diaghilev's 'Russian Seasons' with costumes by Leon Bakst to the piercing paintings of

Helena Heinrichsone, *Coquette*, 1993, oil on canvas

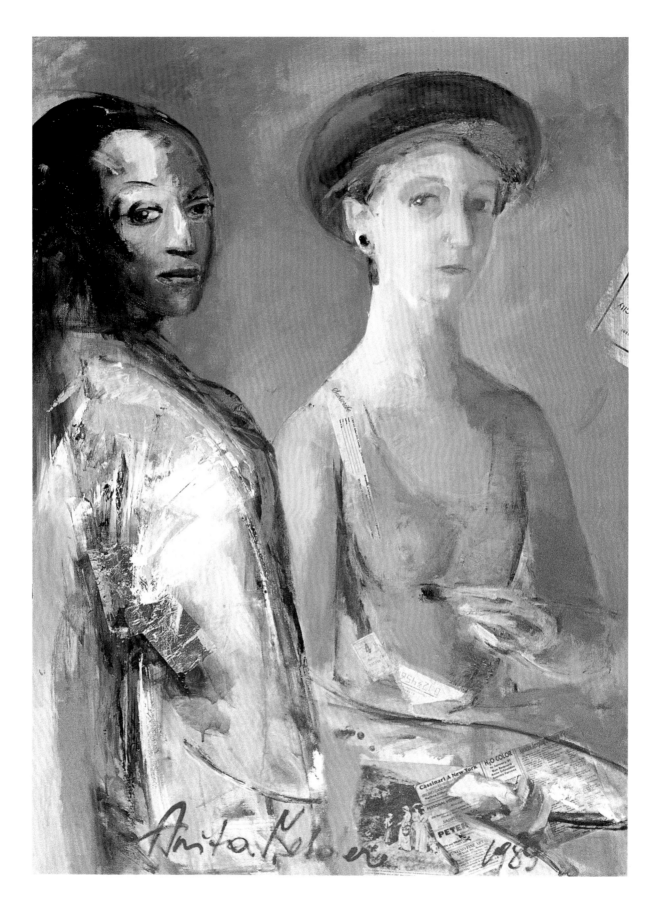

Filonov, the black-and-white graphics of the Soviet 'men of the sixties' to the bright eclectic works of Shemiakin. Bartenev heralds the end of one narrative and the beginning of the next. The narrative is history. But is it really the end of history, or simply the *fin de siècle?*

Postscript

'Russia combines several historic and cultural ages from the early Middle Ages to the twentieth century, from the initial stages preceding the cultural state to the very summit of world culture . . . All countries combine many ages. But the enormous size of Russia and the specific nature of her history have brought to life unprecedented contrasts and oppositions.' *Nicholas Berdyaev*

NOTES

1 For this information see Charles Jencks, *Post-Modernism: The New Classicism in Art and Architecture*, Academy Editions, London, 1987, p13.

2 Wolfgang Welsh, 'Postmoderne Genealogie und Bedeuntung eines umstritten Begriffs', *Post-modern oder Der Kampf um die Zukunft, Hrsg. von R. Kemper*, Frankfurt a.M., 1988, p33.

3 Frederick Jameson, 'Post-modernism, Or the Cultural Logic of Late Capitalism', *New Left Review*, no 146, July-August 1984.

4 Michael Epstein, 'Sovetskii Soiuz - rodina postmodernizma, ili kak zhit posle budushchego?', *Soglasie*, no 42, 15-21, October 1990.

5 See Jean-Francois Lyotard, *The Post-modern Condition: A Report on Knowledge*, translation from the French by Geoff Bennington and Brian Massumi, foreword by Frederick Jameson, Manchester University Press, 1991, p11.

6 'Massovaya kultura i sovetskoe izobrazitelnoe iskusstvo. Kruglyi stol', *Iskusstvo*, no. 2, 1988, p22.

7 'Post-traditsionalism' Vystavka rabot gruppy molodykh zhivopistsev Latviiskoi SSR. Katalog, SKh. SSSR, Moscow, 1988.

8 Alexander Iakimovich, 'Drama i Komediia kritiki', *Iskusstvo*, no 6, 1990, p48.

9 Renato Poggioli, *The Theory of the Avant-Garde*, translated from the Italian by Gerald Fitzgerald, the Belknap Press of Harvard, Harvard University Press, Cambridge, Mass and London, 1968, pp6-7.

10 *op cit*, Michael Epstein.

11 Andrey Kovalev, 'K voprosu o granitsakh primeneniia terminov "postmodernizm" i "avangard" k sovetskomu iskusstvu perioda perestroiki', *Iskusstvo*, no 10, 1989, pp77-78.

12 Paul Crowther, *Post-modernism in the Visual Arts, Post-modernism and Society*, edited by Roy Boyne and Ali Rattansi, Macmillan, 1990, p243.

13 Vladimir Glotov, 'Beseda s koroliom kitcha, Interview with Ilya Glasunov', *Ogonyok*, no 51, 1989, p8.

14 Andrey Bitov, 'Povtorenie proidennogo', *Znamia*, 1991, no 6, p196.

15 Melvyn B Nathanson, ed., with an introduction by Jack Burnham, *Komar and Melamid: Two Soviet Dissident Artists*, Carbondale and Edwardsville: Southern Illinois University Press, 1979, pix.

16 See 'Natsionalnye traditsii i postmodernizm. Zhivopisi skulptura 1960-kh-1980kh godov v SSSR', Gosudarstvennaia Tretiakovskaia Galleria, Moscow, 1993, and the aforementioned publications.

17 Charles Jencks, *Heteropolis: Los Angeles – The Riots and the Strange Beauty of Hetero-Architecture*, Academy Editions, London, 1993, p9.

18 Interview with Charles Jencks, October 1993.

19 Interview with Andrey Bartenev, December 1993.

OPPOSITE: Anita Meloere, *The Turin Portrait*, 1989, oil on canvas, 130x90cm (Latvian artistic school), The Latvian Foundation, Riga; ABOVE: Francesca Kirke, *Painting*, 1990-91, oil on canvas, 130x150cm (Latvian artistic school)

ANDREY BARTENEV
THE FLOWER OF THE SNOW QUEEN

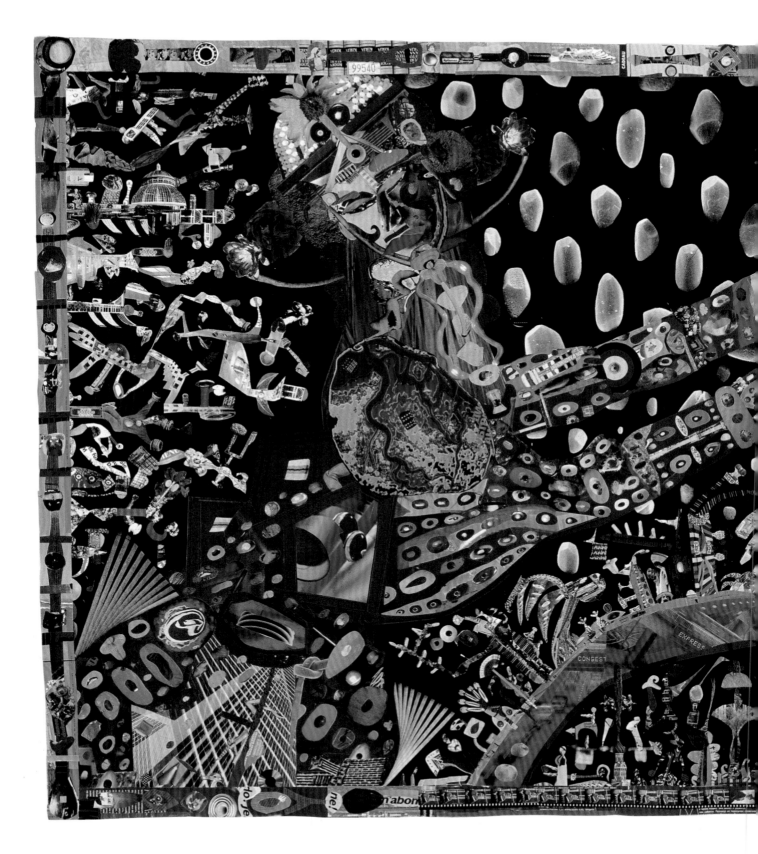

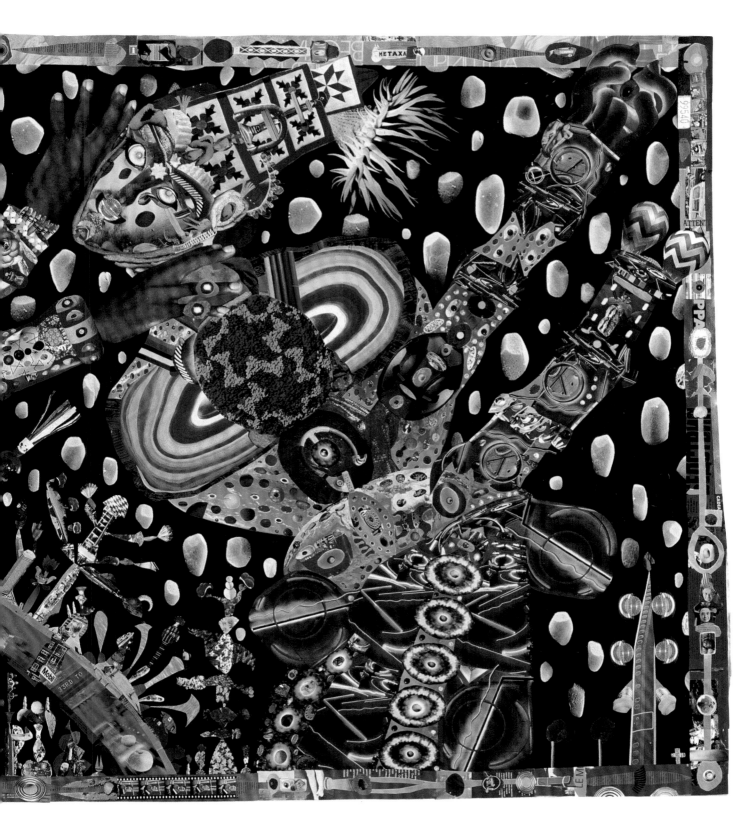

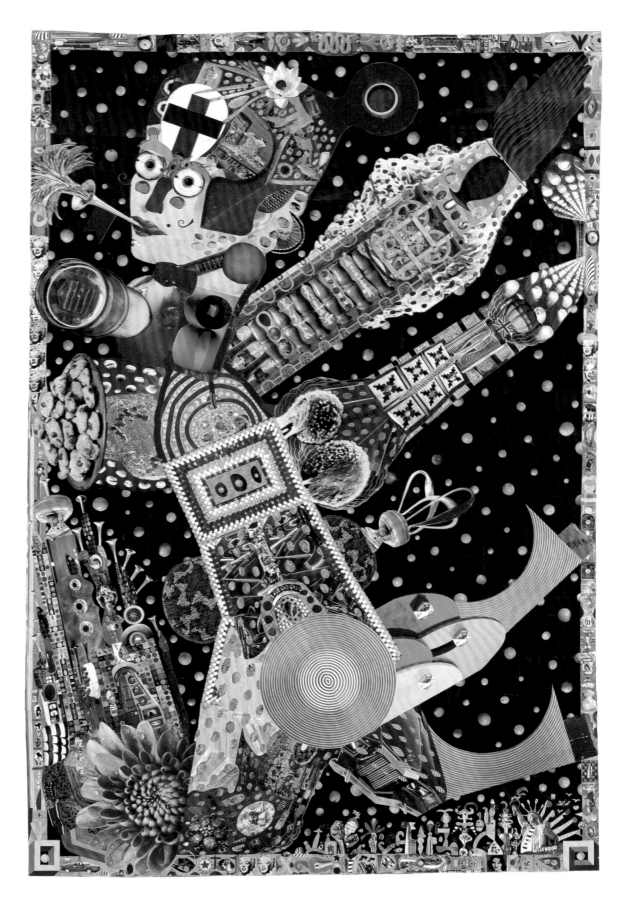

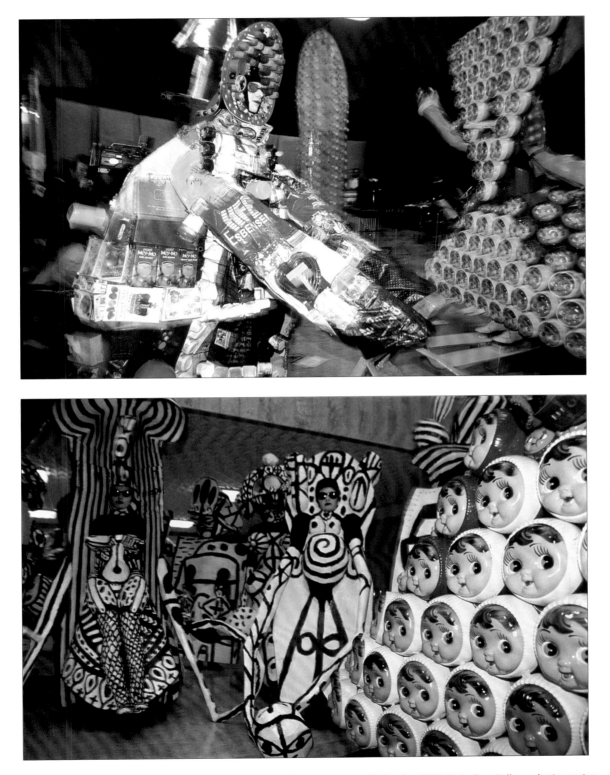

p50 The Frog Queen from the performance of *The Flower of the Snow Queen*, 19 October 1993, Tretyakov Gallery, plastic, papier-mâché, constructors: P Gimatdinova, M Tsigal, photo Gleb Kosorukov; p51 *The Flower of the Snow Queen*, photo by Gleb Kosorukov; pp52-53 Andrey Bartenev in the kokoshnik (Russian peasant-woman's head-dress) of the Snow Queen, from the series; 'The Snow Queen', authors/constructors: A Bartenev and R Gimatdinova; pp54-55 *I am a he-fairy; I am a beautiful he-fairy*, 1991-92, collage, 127.5x243cm, photo Vladimir Frideks; p56 *Self-Portrait in the Wedding Attire of the Bird of Paradise*, 1992, collage, 228x148cm, photo Vladimir Fridkes; p57 above Kay and the Snow Queen from the performance of The Flower of the Snow Queen, plastic, papier-mâché, constructors P Gimatdinova, M Tsigal, L Kadykina, photo Gleb Kosorukov; p57 below Objects from the series 'The Botanic Ballet' during the performance of *The Flower of the Snow Queen*, plastic, papier-mâché, photo Gleb Kosorukov

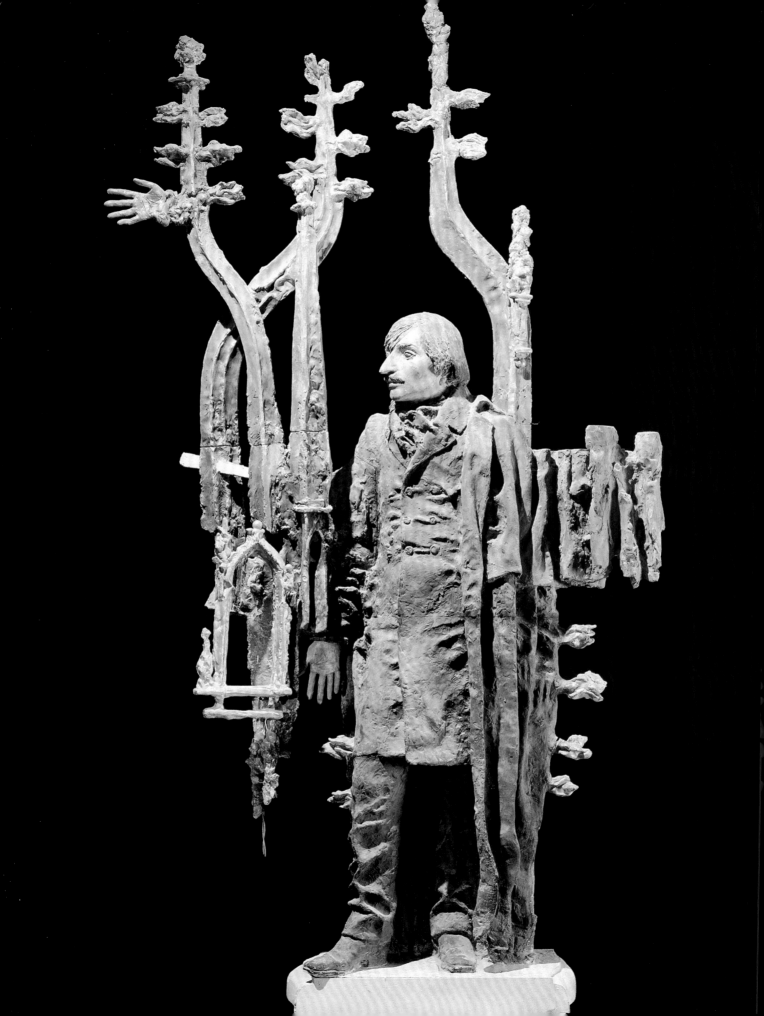

SERGEY ORLOV
THE GARDEN OF ARCHITECTURE
AT THE MEETING OF THE MILLENNIA

S oviet and post-Soviet art of the 1970s to the 1990s, consisting of numerous interpositional trends, was formed at the junction of diametrically opposed categories. Therefore any model chosen as representative of this art turns out to be rather conditional and one-dimensional, and the division along the official/unofficial line is unfruitful. At the same time, between Socialist Realism and the classic Soviet Post-Modernism of the 1970s and 1980s (Sots art), there exists a thick layer of 'nameless' art, not limited to these two trends.

One could probably find the lodestar in this labyrinth by merely combining several models, 'constructed' from opposing categories.

One of the antinomies and specific features of Soviet/post-Soviet art of this period is the feeling that it was balancing on the brink of a carnival attitude to the world, and on the verge of the realities of mass culture.

Carnivality and Rabelaisianism can be considered the inalienable bases of Post-Modernism. They express the necessity of liberation from total standardisation of life, from the power of false norms, from the stereotypes of primordial fear. The main Rabelaisian motifs are the parody of death/resurrection (victory in a dangerous situation, victory over the wizard's spells); the parody of the inventory of objects; the destruction of their standard relations in order to remove both ideological loading and the aura of 'daily-life fetishism'; Utopian imaginary geography which allows one to travel between different epochs, styles, countries and continents; and finally the image of a grotesque body manifesting itself in various hypostases from zoomorphic and foetal to carnival and masquerade forms, and to the motifs representing the image of socio-biological regression.

The carnival is a flash, an explosion, a liberation from oppression. On the other hand, the objects and attributes of mass culture are associated with the infernal world (and in the narrower sense, with the atmosphere of totalitarian power). This atmosphere can be gloomy, depressing and prison-like but it can also be full of some grotesque 'Neanderthal' optimism instilled in man-turned-puppet (the triumph of a social paradise). Carnival culture brings back to life, while mass culture most often suggests the cult of insipid daily life leading to the fading and depersonification of the individuum. The carnival rejects any hierarchy. Soviet/post-Soviet mass culture, on the contrary, is multistaged, revealing at least two levels: the official (stereotypes of propagandist slogans, social clichés and norms of behaviour) and 'unofficial' – the daily life and psychology of 'average' citizens.

In contrast to carnival, mass culture can be considered a verification of the unreality, artificiality and cadaverousness of the ambience in general. Artificiality of life substituted by mass culture is the main theme of Soviet classical Post-Modernism. In easel works (paper architecture), object-pictures and installations, the role of documental material is often played by attributes typical of 'Soviet fashion' (hats with ear-flaps, felt boots etc), surgeons' kits, glass tubes, burn-out lamps and finally the

Leonid Baranov, *Gogol*, 1987, plaster, 180cm

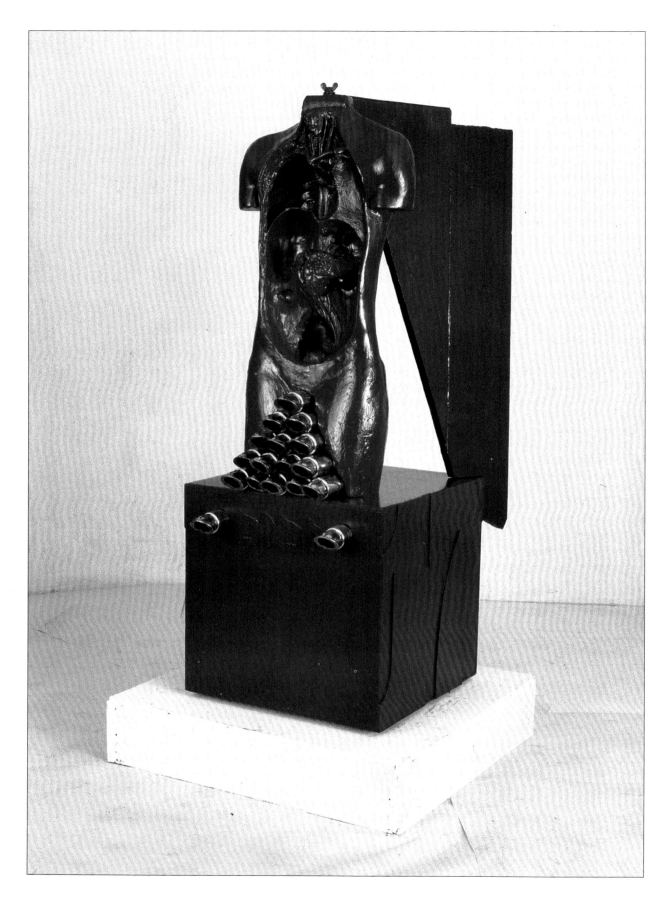

objects of the highest hierarchy – orders and ideological slogans. They constitute an ephemeral, illusory and at the same time frightening 'environment'.

The expansion of 'mass culture' (both everyday and ideological) spreads not only to society but also to nature. This motif is specifically interpreted by Eric Bulatov and Ivan Chuikov. In the textual landscape of Bulatov, *The Sky, The Sea*, the inscription 'The Sky' is lifted into the highest hierarchical, 'divine' zone, while the word 'sea' is unrolled like a carpet at the foot of the sky, producing an association with the tamed sea of life.

Chuikov's 'pictures of nature' emerging on walls or windows nailed up with plywood, are interpreted as a refined tint for the subsequent coarse brushwork. The artisan's hand armed with a brush seemingly recolours nature into the standard colour of a warehouse.

The realities of mass culture turned out to be a heaven-sent influence for the art of the 1970s to the 1990s. They are either documentally verified or reworked in a popular or carnival spirit. There emerges a nearly Rabelaisian motive of reality's reinventory.

The nominative principle established in Soviet art of the 1960s is still triumphant today. Most often, the sum of objects, advertisements, road signs and so on, is interpreted as an indicator of social inferiority and overall limitation of the means of existence. At the same time, the reinventory bears the idea of innovation. Man gets a chance to see his life-niche from outside, in a new context, condensed and focused in a homogeneous macromolecula.

Such a bizarre cast from reality emerges in the assemblages of Boris Smertin. His composition *12A Podkopaevskii*, is a collection of warnings, the sign-boards of various organisations, the name-plates of officials. Reshuffled, these objects create a parodied image of the overturned social hierarchy, the illogical and unviable superstructure. It is not very far from the innovating carnival reinventory of the world.

The totem sculptures of Boris Orlov, manifesting the transition from Sots art to the new post-modern mythology, are an excellent example of the carnival reinterpretation of realities. Orlov accentuates the antinomy of the superior and the inferior, of the triumphant iconostasis and the strip of carpet, of the horizontal and vertical zones. In the vertical 'divine' sphere, the role of textual hierarchy is played by various medal ribbons of different ranks and orders, and medals forming the levels and sub-levels of senior administrative structures. The lowest horizontal sphere is ruled by all-embracing persistent commands repeated time after time: 'Get ready!' 'Attention!' etc. It is precisely their repetition that forms the strip of carpet of the sea of life.

The double model of society is also portrayed by Boris Orlov's 'two-facade' compositions. The front is a hierarchy of administrative structures (iconostasis of regalia), while the reverse imitates the interior of a cave, resounding with the polyphony of the marginal world with its market-like hubbub of labels, stickers, packages and love-letters . . .

The antinomy of carnival and mass cultures can be supplemented with two more categories: daily life and magic factors.

Post-Modernism of the 1970s, and Sots art in particular, has stronger relations with the level of daily life, with social metaphysics. The universal motifs of the recurring closed cells, graphics of the unit in formation, of the line, direct references to social clichés, can be attributed as a sign projection of sufficiently real phenomena. The magic

Igor Makarevich, *The Sound (The Man-Fly)*, 1987, mixed media, 140x54x66cm

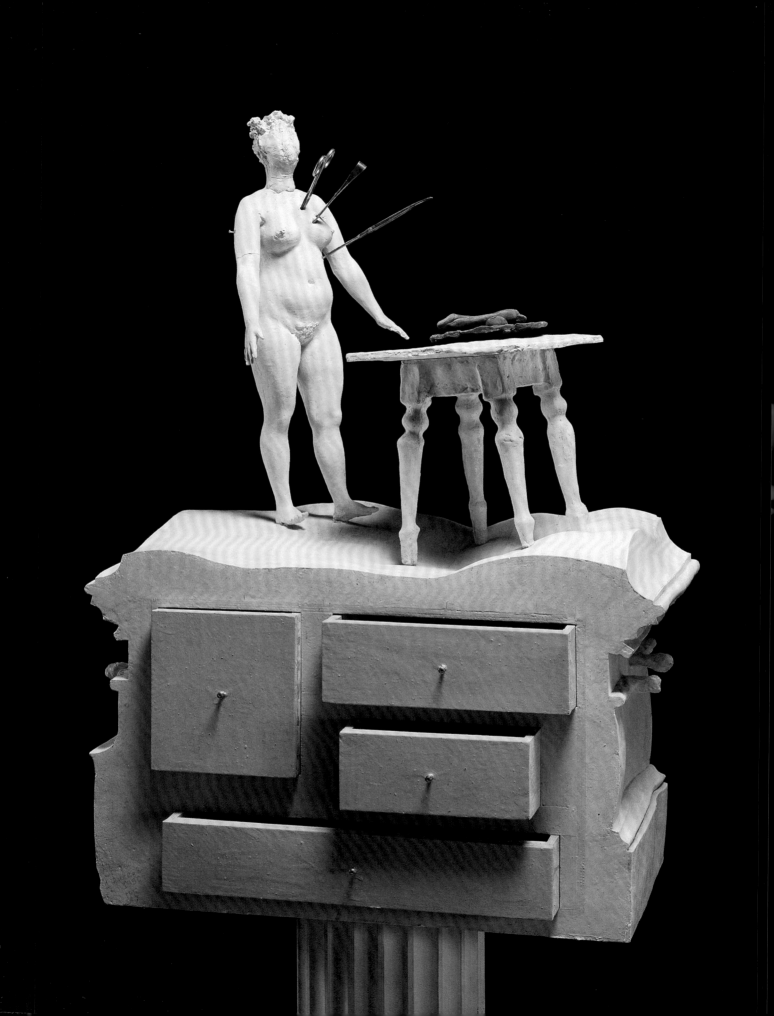

motifs appear only in the form of a parodied sacrament, thus dethroning the ossified ideological stock phrases.

Nevertheless, there came to life in the 1970s and 80s a so-called metaphysical trend not connected with any specific social allusions. This time the object of meditation was the notion of mutual intersection of a triad of substances: the life of man, the life of an object and the mystery of superior knowledge of the spirit unattainable by rational knowledge. Thus, the Estonian sculptor Iaan Soans 'operates' with sacral objects (the sarcophagus, the pyramid) and interprets the traditional post-modern motif of the resurrection of the ghosts and shadows from the past, capable of bringing irremediable harm to the world.

The sculptures of Igor Makarevich evoke associations with the ancient proto-religious ideas of taboo objects avenging the man who dares to touch them by instilling in him a demonic force. Under the influence of this force, the man is converted into an insect-like creature turned inside-out.

The magic line was manifested most graphically in the 1990s in the works of Sergey Artamonov. His objects – the carcasses of ancient giant fishes, pyramids, sarcophagi, obelisks, symbolic signs resembling rock paintings – as if engaged in an argument on primogeniture, lay claim to connections with the oldest and deepest strata of life and culture.

In Artamonov's works the motif of a hollow object is sacrally sensualised: the pyramids with an empty funeral chamber, the sarcophagus without a mummy, the empty space 'bandaged' with metal bands showing the shape of a figure, bust, head . . . The bodiless object 'narrates' either its eternal wait for the advent of the Goddess, or the 'drain' of flesh and its transition into some supratemporal spiritual substance. The hollow ribbon which covers and silhouettes, 'pining for being filled up', ascends to the idea of a natural cycle, the death and resurrection of Osiris. And even if time is counted, it is done not by hours and events, but by the cycles of growth and decay of grass sown in boxes/sarcophagi. One of the installations by Artamonov represents a symbolic bed with cosmic landscapes depicted on its ends in sown grass. That is how a specific magic image of the Universe is created.

The compositions of Artamonov and other artists of the 'New Generation' betray one essential feature of the local Post-Modernism of the 90s: that is the combination of the 'object and sign' and 'magic' lines, as well as the combination of different textual systems. Post-Modernism of the 'second generation' uses the method of paradoxical synthesis which deprives the object of its objective-documental and everyday contents and transfers it into the sphere of intellectual associations.

Within the 'magic' trend, the plastic metaphysics of Leonid Baranov look outstandingly unique. His work takes a step forward from the tradition of Russian culture according to which the antithesis of daily life is adequate for the juxtaposition of the dead and the living.

The dead environment of Gogol's dead souls is created by the close and isolated cells of estates, rooms filled with old cupboards, chests and boxes. For Dostoevsky, the ominous metaphysical character was the room – Raskolnikov's sarcophagus, the grave of all hope, the cradle of ominous plans.

Baranov is surprisingly skilful in bringing together oppositions – metaphysics and irony, psychologism and grotesque, languor of the spirit and 'languor of daily life'. According to his interpretation,

OPPOSITE: Leonid Baranov, *Chest of Drawers: Lucretia*, 1991, plaster, 100cm; FROM ABOVE: Sergey Artamonov, *The Slow Flow of Time*, 1991, wood, textile, sand, 180x124x60cm; Sergey Artamonov, *Small Obelisk*, 1991, wood, metal, textile, 60x80x80cm

FROM ABOVE: Leonid Baranov, *Pushkin and his Time*, 1977-81, plaster, 11 figures: 135-145cm, column: 350cm (The Ludwig Museum, Cologne, Germany); Nikita Gashunin, *The Monogram*, 1991, relief, mixed media, 100x63cm

Dostoevsky was susceptible to the influence of the unworldly mysterious forces which either raised him heaven-high, or incarcerated the writer in a plaster box-wardrobe, or threw at his feet the witch-temptress. There emerges a certain author's variation of the temptation of St Anthony.

Baranov offers a rather Gogolian version of reification. Thus, the personified staircase is noticeable as the image of a genuflecting woman carrying on her back a 'ladder of honour' with anonymous busts.

Baranov makes use of a specific 'subjectless subject'. In the composition *Pushkin and his Time*, the deductive multiplication of personages comes into effect. Here are Nicholas I as an incarnation of destiny, several Natalya Goncharovas incarnating several destinies, two Gogols who decide which of them is more authentic, and finally three Pushkins divided by space but eager to reunite.

There are heroes, but there is no definite subject, least of all a story. The theme is orchestrated by numbness itself, by mysterious destiny hiding denouements and finales. On penetrating this enchanted world, the spectator feels the effect of time standing still, as if the worlds of dreams and reality come together with all memories, misgivings and whims of life, and with the inevitability of the eternal laws.

The works of Baranov and other artists of the 'magic' trend of the 90s differ strongly from those of the classical Soviet Post-Modernists of the 70s and 80s, first of all by the absence of any direct social allusions. However, if we assume that Post-Modernism as a certain superphenomenon contains diametrically opposed factors, then it becomes possible to distinguish at least two branches of the movement.

Like step-brothers, Post-Modernisms I and II coexist in one time and space, though they have a number of distinctive features. Post-Modernism I (the elder brother) has a penchant for cataloguing, operating with texts and documental objects and social fetishes; it absorbs Pop Art and Sots Art. Post-Modernism II (the younger brother) refuses to perceive the facts of current life, is not over-interested in political metamorphoses or lifestyle. The standard row of ready-made objects is not a purpose-in-itself for him but just a means. Out of these objects, he projects something magnificent, unique and mysterious, carnival and magic, mighty and ephemeral.

Different in principal in many respects, the 70s, 80s and 90s can be represented as a non-linear, but coherent entity. During this period, three hypostases of the word meet each other. The first is the word as a subject, narrative motif, story about a possible or impossible event. The second is the word as a row of objects or signs, or a text as such introduced into the composition of a work. And finally, the third – most indefinite and vague – hypostasis is the word as an intuition and presentiment. In this case, one could speak of the word as something under-manifested, semi-born and unspoken.

Let us imagine the following scheme: from the word/subject two vectors are stretched to the two remaining categories – the word/object (sign) and the word/intuition. This will be an approximate and conditional model of the development of Post-Modernism. It can be applied, first of all, to Soviet/post-Soviet art for it determines the two ways of its evolution towards the object and magic (metaphor). Nevertheless, we must immediately specify that despite the difference the two lines have many crossing points, and from time to time they merge completely.

The 'alternative', magically fantastic Post-Modernism does not rupture

its links with the basis of objects and texts, but interprets it in either a carnival or a metaphoric manner. This is excellently illustrated by the works of Nikita Gashunin, Andrey Bartenev and Boris Orlov.

The very material from which Nikita Gashunin constructs his objects is metaphoric in itself, because it is nothing but the details of various 'do-it-yourself' games. The motif of game, unrestraint, freedom and improvisation, becomes clear from the very beginning. There emerges an association with the work of a child – spontaneous, intuitive and emotionally open. Getting down to assemble a fantastic building or metal, Gashunin never knows the final results, relying on his intuition alone.

The basic elements of the composition – standard metal modules – are essentially an unemotional, mathematically verified text. But at the same time it is a game and the opportunities are numerous. Gashunin accepts the magical rules of the game and creates images full of fantasy and imagination.

In the bisectional object-picture, *Diptych*, 1990, there appears a mysterious vision of the night with a multitude of shining stars, exotic grasses, flowers and imaginary cities. A post-modern image comes into being. It is that of a paradise and Utopia of dreams, a garden of forms and structures . . .

Unlike the conceptual and 'cataloguing' style of Post-Modernism, the new Post-Modernism of the late 80s to 90s is characterised by its spontaneous and nearly unrealised syncretism. Its base is a specific semi-representation (or representation of motifs not fully manifested, or expanding ornamental structures and forms) which implies numerous opportunities and options including the alternatives of development and evolution of form.

Motifs can unexpectedly come to the surface in a dream, or be spontaneously materialised in paint, can be decoded in the bark of a tree, in the structure of rock, in the pattern of the clouds, in the silhouette of a shadow. Such a method of artistic work, free of any dictate of rationality, is vividly exemplified by the sculptural compositions of Igor Khristoliubov. The 'model' chosen by the artist is fallen leaves, dried and rolled up. In their 'second life', the leaves form a boundless garden of images and shapes.

The sculptor has a poignant feeling of mutually supplementing the contrast between a large spatial volume on the one hand, and graphic unrepresentative structures on the other. There emerges an effect akin to the Borgesian idea of a garden with diverging paths where there is a wide choice of opportunities at the same time. Thus, proceeding from a crossing, one could go along several paths simultaneously. This effect can be found in the majority of post-modern works. Khristoliubov expresses this phenomenon by balancing image and ornamental structure, volume and graphics, speech and dumbness, narrative and mystery, Christian and pagan symbols, all on the edge of a symbol.

In the article 'On the Architecture of the Present Time', Gogol creates the image of a hypothetical town, combining on the same street houses of various epochs and styles (from Ancient Egypt onwards). He presents an idea later transformed into the image of a magical garden of post-modern architecture. This garden is a laboratory of metamorphoses, irony and revelations. Gogol, it seems, foresaw the universality of Modernism. Nowadays, it is Post-Modernism that moves slowly in the same direction.

Igor Khristoliubov, *Royal Leaf*, 1993, wood, 100x45x30cm

65

Without the synthesis of contemporary style, one could distinguish – though with certain reservations – two coexisting levels. The first level is the creation of a specific, semi-parodying 'herbarium' of artistic Classicism. The second is the construction of an imaginary environment and 'intellectual geography'.

The heterogeneous country of 'Post-Style 2' can be defined as an 'architectural garden', bearing in mind that this term acquires a much wider meaning as a model of the world, which is not exactly adequate to its initial content. The garden appears as a conventional space isolated like a liberated spiritual territory ruled by the law, differing from the norms and regulations of mundane life.

It can be a garden of magical architecture, natural landscapes, structures, words, exotic animals, mechanisms and finally, simple shards of broken glass representing the metaphor of the world split apart.

Entering the 'magical garden', Post-Modernism embarks on a rather peculiar mission. Without a hope of getting anything from reality, it creates new models of the global order and places them into the ideal sphere of 'intellectual geography'.

OPPOSITE: Igor Khristoliubov, *The Ascension*, 1991, wood and size, 100x35x30cm, front and back views; ABOVE: Nikita Gashunin, *Dead Weight*, 1988, metal assemblage, 30x20x76cm

ANDREY TOLSTOY
FIN DE SIÈCLE THROUGH THE EYES OF A CONTEMPORARY

What can a contemporary say about the end of the century in which most of his life has passed? He does not have the time-distance necessary for a balanced appraisal of any process, and he considers everything from the 'inside', from within the vortex of events. But such a viewpoint is not devoid of interest, for it leaves space for unprejudiced judgement based on direct experience. This is particularly true in the sphere of art, because its history in the twentieth century has been embedded in criticism to a degree unprecedented in the past. Apropos of this, in so far as it is not the first century of our era which is coming to an end, but the twentieth, there is much scope for comparison, aiding the process of our determinations.

The finis of a large time-span – a century, a millennium – has always awed mankind. We have tried to clarify the image of the unknown future by the means of culture and philosophy, and likewise we have tried to summarise the past. This happened during the eclipse of the Renaissance, in the period of late Classicism and in the age of proto-Romanticism as well as at the close of the nineteenth century. Everybody knows about 'historic' styles, the free juggling of forms and elements of decor which determined the face of eclecticism as the epoch of stylelessness in the architecture, design and, to a certain extent, the fine arts of the second half of the nineteenth century in Europe and Russia. This multi-style entity of specific components was fed by the extant historical conscience which permitted artists to 'hover' freely over the vastness of world culture. The choice of this or that 'historic style' for the design – for example, of a building's facade and its elements, and of its furniture and decor – depended first of all on the taste and financial means of the customer; only then on aesthetic demands. That was how Russian capitals and provincial towns got their share of pseudo-Renaissance and pseudo-Gothic structures, coexisting hand-in-glove with academic tradition, surviving as a living embodiment of the features and values of bygone cultural epochs.

Nevertheless, the accumulation of this means of expression did not become an amorphous and tasteless mass, as it may seem at first glance. This quantitative accumulation resulted in a new quality which summarised and enriched the totality of the recovered 'splinters' of the past, transferring them into a new dimension, that of Art Nouveau and Symbolism. Thus, the seemingly hopeless situation was resolved by success, the grandiose success of the 'last style of the epoch' – the Style Moderne.

Let us turn now to our era. Can we draw any analogies between the trends of the 1880s and 1890s and those of today, a century later? Contemporary art and architecture operate freely with much reference to the art and design of the distant – and not-so-distant – past. But the specific point is that these reminiscences are not purely aesthetic or artistic: the arts of the twentieth century in general and those in our country in particular have been overburdened throughout the century by supra-artistic missions, by ideological and mythogenetic 'ballast'. Ac-

ART-BLYA, The Glass Tower, 1990, coloured glass photo-plates of paper-architecture projects, 500cm, built and destroyed at the Central House of Artists, Moscow

ART-BLYA, Disposable monument in front of School of Art, 1991, beams, plastic, acrylic, 1,000cm (Kiel Gallery 'Nemo', Germany)

cording to contemporary concepts, Post-Modernism as the state of existence of civilisation embraces the most diverse spheres of the life of mankind which cannot but influence each other. Politics influences culture and art, while certain cultural processes in their turn influence public life and even the environment. The history of Russia has seen everything, and in the twentieth century the forces of destruction gained the upper hand over the forces of creation; perhaps only now are we starting to level off this imbalance.

Currently we are living in the situation of a universal 'Post-'. In the socio-political field it is the period of post-totalitarianism, post-socialism, even post-civil-war and post-*putsch*. Whatever efforts we make to rid ourselves of the vestiges of the past, alas, they remain with us. Nevertheless, in the domain of culture and art, not only artists, writers and cinematographers, but also art historians, literary critics and culturologists willingly and voluntarily use the old and tested images, forms and stylistic approaches which often become clichés.

The subject of the exhibition and conference at the State Tretyakov Gallery – Post-Modernism and National Cultures – makes it possible to approach the problem of quoting in a more differentiated way. And indeed, how can we appreciate the artist from the late twentieth century who addresses the archaic strata of national cultures and archetypes of universal importance? What motivates him – a detached and rational 'play of the mind', or an emotional 'supraconscience' of the intrinsic values of his own cultural memory? And if an appeal to images and archetypes of remote antiquity means the study of tradition, why cannot the use of the means of expression of the twentieth century's art in a new context be acknowledged as such?

It is apparent that the problem of the context is the key problem of the whole Post-Modernistic culture. Charles Jencks wrote in his book on the language of post-modern architecture[1] about 'double-coding' as the principle of this architecture; perhaps it would be better to say its language, for only the understanding of architecture (and any other art) as a language makes it possible to classify this or that author as a Post-Modernist. The code and the key to it are determined by the context in which a Post-Modernistic work of art is comprehended.

So what is the context of contemporary artistic culture? The last bulwarks of Socialist Realism are destroyed, and its remaining adepts can now find admirers of their *oeuvres* (as something exotic) either outside Russia or amongst the local wealthy businessmen. Sometimes these works represent craftsmanship of a relatively high quality.

The same destructive influence of the context has made its imprint on the whole Russian Underground movement, beginning with Conceptualism, of which many leading representatives, who determined the development of this trend in the 1960s and 1970s, now live far from Russia.

Their followers both in the field of 'criticism of pure mind' – Post-Conceptualists from the mid to late 1980s (the 'Fly-Agarics', the 'World Champions', the 'Medhermenautics' etc) – and in the sphere of social grotesque (Sots artists), who had ironically reappraised the true and the illusory values of Socialist Realism, have also become part of the history of contemporary art. Their merit is not confined to a simple destruction of rusty stereotypes, slogans, artistic and verbal clichés; it also includes a specific levelling and recoding of their language. They operated with the culture of the near past as with a heritage which can be used as a

material for building something new and original.

The early 1980s were marked by the advent of a Pleiad of young artists who saw their primary mission in the preservation of the imminent plastic qualities of painting – the texture, the colour and the volume – as well as the free use of these elements throughout the whole space of the history of world art (Savadov and Senchenko, Kotliakov, Roitburg, Khorovskii, etc). From the point of view of stability in the development of art, their works represent an analogy of the movement of Italian Trans-avant-gardia and the German 'New Wild'. Strictly speaking, it is these painters who are traditionally labelled by our art historians 'Post-Modernists'; for they appeal in their art to the heritage of antiquity, the Baroque, the Renaissance and the eighteenth century, but they bypass the art of the twentieth century with all its avant-garde experiments which now have also become part of our heritage. Nevertheless, the application of the term 'Post-Modernism' as far as the art of these painters is concerned, narrows the concept to just one of the artistic trends of the late twentieth century.

However, as it has already been pointed out, we are living in the situation of a general 'Post-'; and this situation is Post-Modernistic. The most grotesque and illusory models constructed by Conceptualists and masters of Sots art have been realised in our lifetime. The sequence of deaths of Secretary-Generals, the rapid acceleration of the *perestroika* movement ('further and further and further . . . ') along the route of dethroning and debunking of the seemingly unshakeable mainstays of totalitarian society, have resulted not only in the collapse of this society but also of the empire which supported it. Finally, we have become not only eye-witnesses but also participants in two outbreaks of civil war of which the first – contrary to the popular saying – turned into a farce, while its successor turned into a tragedy. And this tragedy, as if it were some mesmerising play, was observed by millions of onlookers both on the TV screen and on the spot. In the mind of the contemporary human being everything is confused: real spiritual values coexist with informational and cultural units forced upon him by the news media. Even the political elite of the country cannot escape getting involved in the game, the rules of which are dictated by the post-modern situation. It is sufficient merely to analyse cartoons and to glance at the headlines, and the truth of this becomes clear.

The perception and reproduction of various elements – which are combined into some new entity within the framework of contemporary artistic phenomena – often come at a superficial iconic level, sufficient only for a recognition of the primary source, and not at the level of the symbol. This characteristic feature enriches Post-Modernism in art with an amazing ability to establish direct contact with the spectator. It can be seen in the works of the Moscow ART-BLYA group (including Zhitskii, Savin, Labazov and Cheltsov).

Having created the concepts and put into practice the phenomenon of 'art valid for one occasion only', the group creates its objects and installations of such ostentatiously worthless materials as newspapers, cellophane and cardboard boxes. The activity of ART-BLYA realises the experience of the art of the environment and at the same time appeals to the figurative and compositional stereotypes of world art from antiquity to the Soviet epoch. The winged geniuses of polyethylene, ceremonial portraits on newspapers and cellophane, the whole spatial zone of

ART-BLYA, *Kunstkamera*, 1993, paper and tape (Gallery A3, Moscow)

'makeshift' and seemingly unaesthetic materials such as corrugated cardboard, are just some of the examples of the group's creativity. One of the most recent works of ART-BLYA was an impressive sphinx, erected in Krasnoyarsk for the 'New Territories in Art' festival. It was made of scaffolding, tree branches and an enormous amount of cardboard tare in polyethylene packing. Placed in front of the Cultural and Historical Centre of Krasnoyarsk (formerly the Lenin Museum), one of the largest buildings in the country, the sphinx with its small beard and moustache hinted indirectly at the recent function of the gigantic building. Thus, the relatively young tradition of Soviet art drew a parallel with the most ancient cultural tradition of Egypt. For the contemporary artist, when he creates his works using various elements from the past in order to bring into being original and pioneering concepts, all traditions are equally valuable and equidistant from the present.

Objects and installations of today organise around themselves a space of high conceptual intensity. Each spectator reads the context of this or that work according to how prepared he is and thus achieves satisfaction from what he sees. In the post-modern situation, there should be no misunderstanding between the artist and his audience, for art is deliberately oriented towards a dialogue with any kind of audience. Thus, the aforementioned sphinx erected by ART-BLYA served as an excellent playground for children, while at night, lit by garlands of electric bulbs, it became a focus for performances and various esoteric artistic activities. The field of vision of both the post-modern artist and the post-modern spectator covers a whole range of cultural traditions. Perhaps the best example, in this context, is the avant-garde tradition of the twentieth century, the free development of which was often interrupted artificially in our country. It was less than a decade ago that Russian culture was once again freed from the narrow frames into which the totalitarian establishment was eager to squeeze it. Once more, as on the eve of the twentieth century, it took on an amplified impulse to regain what had been omitted. This resulted in the spread of artistic awareness and subsequently, the awareness of the mass spectator to the newer horizons

ART-BLYA, *The Silver Hall*, 1992, walls and floor: foil, metal; figures: mixed media; for Festival and Exhibition of ♂

opened up by the arts in the twentieth century, leading to the simultaneous combination of several stages of logical evolution of stylistic trends as they are generally characterised in the Euro-American tradition.

In order to illustrate this properly, take for example the installation 'Gallery, Forward!' by the young artist Ter-Oganjan which represents an old Moskvich car filled with various replicas of masterpieces once created by such titans of the twentieth century as Mondrian, Rothko, Kline, Pollock, Warhol and Lichtenstein. These replicas, although outwardly very close to their originals, in fact parody them, being made up of ovals for photo-portraits, cards and discarded tins. However it was these 'domestic masterpieces' that the artist chose to accompany him on his imaginary journey along the roads of world art history. And the dilapidated Moskvich speeds along carrying its passengers – the artist and the critic who dares to pronounce his judgement as a contemporary of the century which nears its end.

When embarking upon an attempt to appreciate current events, the contemporary (that is, myself) used the experience of the previous *fins de siècle* and thus was personally included in the post-modern situation, finding in the past an explanation for ongoing processes. Based on this experience it becomes possible to conclude that the accumulation of elements with different qualities cannot be infinite. It is more than probable that the post-modern data-bank, which consists of images, clichés and the attitudes of various eras, can give birth to something which is basically new, as has happened in the past. For now, one can be confident in arguing that the intrinsically contradictory use by present-day culture and art of the 'riches of the past' has a clearly creative vector of accumulation which resists the destructive tendencies of preceding decades. The near future will show the results of this accumulation as far as the arts are concerned.

NOTES
1 Charles Jencks, *The Language of Post-Modern Architecture*, sixth edition, Academy Editions, London, 1991, p12.

ART-BLYA, *The Sphinx*, 1993, scaffolding, beams, trees, cardboard boxes, paper, plastic, 600cmx1200cm, for New Territories of Art Festival, Krasnoyarsk

YURY LEIDERMAN
NICHOLAS FEODOROV AND
VENUS STOCKMAN

The uncertain nature of contemporary art is manifested primarily in the decline of the autonomy of exhibition space. This space – even before anything is accomplished in it – is already crammed with various aspects of time and place (or strategic 'introductory situations') which the artist has to take into account slavishly. In fact he can accomplish nothing, for everything has already been introduced through the text accompanying the exhibition. The textural interval between these texts is very wide because, apart from the concept of the exhibition, it includes the 'situation at the given moment' (either national or worldwide), and the architecture of exhibition space is no longer a mere container of emptiness to house exhibits but represents in itself some rigid and dictating text. Another powerful introductory situation is the geographic problem and the search for certain specific authenticities in all marginal locations from Ireland to Russia, though it is clear that such an authenticity will always be artistic due to the vague poetic text created by the combination of all other circumstances and introductory situations.

Thus the presence of the artist is pre-empted, and the sets of interlaced circumstances prompt him 'from above' in his own future work. The model of contemporary art is actually a *kunsthalle* warehouse where circumstances, not works, are stored; a hall, redesigned on the premises of a defunct factory, to exhibit the determining circumstances of time, place, country and weather. As a rule, these circumstances are depressingly monotonous, and artistry delegated by them thunders amidst bravura romantic music.

How can one escape the characterisation prescribed by text-dominated space? Perhaps this cannot be done for it will result in the disappearance of 'contemporary art' as an autonomous humanitarian phenomenon related to three-dimensional space. Some support the idea of numerous alternative spaces – villages, forests, computer networks, Martian chronicles – but all these places prove not to be spaces but just different facets of certain texts. Nevertheless, one more outcome exists which deals with the categories of absence, dispatched messages and graphomania. Artistic objects can still be exhibited in museums and galleries but have only the function of indicators for some circumstances of the event and space situated outside, as such being independent of the latter. The eurythmics of such works gravitate to a pointer which directs our glance to something that cannot be seen 'from here' anyway. At best, we will see its vague, approximate and pitiful reflection. The observer knows that his vision is 'incorrect', that the main action takes place somewhere else, far from here, but he can neither improve his vision nor even turn his head. This is guaranteed by circumstances, the custodians of time and place. The visitor is left with the knowledge of some unverifiable absence unravelled 'somewhere there'. Artistic realisation is eliminated in expositional space by the presence of the spectator here and the author there. (The same strategy has been employed by the

Yury Leiderman, *The Death of the Poet*, 1993 (detail), mixed media

group 'Collective Actions', whose work takes place mostly in the alternative space of 'trips to the countryside', risking being stuck in the interpreting inverted commas of the 'local idea'. Nevertheless, even in this case Andrey Monastyrskii has managed to develop a number of countermeasures.)

A simple example of such works is a columbarium niche with a memorial tablet. The only plastic reality facing us is the tablet itself with its specific cracks, its damp-stains and its touching epitaph. And yet we understand that this tablet just indicates a disappearance, the absence of somebody and our loneliness. Physically, behind the tablet there is emptiness, metaphysically 'everything'. The text, material, design and choice of script are essential here only as an indication of other-worldliness. Looking at the memorial tablet, we realise that we are looking 'in the wrong direction' and cannot see what it is pointing at, cannot even ascertain in what area it lies.

In the columbarium, visitors find themselves subconsciously submerged by the process of subtraction. Reading the memorial inscriptions, they automatically subtract the year of birth from the year of death, calculating the longevity of the deceased. If somebody has died young, there is a sigh of regret; if the length of life has been sufficient, the likely response is relief – well, well, this person lived long enough after all. Thus, subtraction at the cemetery turns out to be a source of vague narratives swallowed on the move – the only narratives created by subtraction and not by addition or multiplication. (There also exists the method of division offered by marginal philosophy.) The volume of ashes hidden behind memorial tablets is minuscule. In essence, there is nothing but emptiness, and we subtract one four-digit number from another in order to invent a narrative of the emptiness with a name. Communications of subtraction embrace and permeate the columbarium, creating a homogeneous aura of pitiful, clumsy and semi-senseless narrative. And at the same time the only purpose of this narrative is to reactivate the space of absence in the form of the world of silent and abandoned interpretations.

In the columbarium of the Donskoy Monastery in Moscow there is a memorial niche to one Venus Stockman who was born in Denver, USA, in 1904, and died in Moscow in 1936. The only difference between this tablet and the thousands of others is the bilingual inscription. As soon as we notice this, we become enchanted not so much by the Roman letters as by the interval between the two dates. We realise that Venus lived for only thirty-two years. This leads us to meditate on how she came to Moscow, thus approaching the theme of the 'Internationals', victims of Stalinism, and the millions of other narratives we know which are always ready to serve us as predetermined circumstances and 'superimposed' situations in a possible interpretation. Though its results will inevitably be different from other interpretations offered to us by tireless artistry, the 'reality' of all these narratives is just an indication of emptiness and absence: absence of a hero here and absence of us there.

The philosopher Nicholas Feodorov liked to use the diminutive form of the noun 'soul' when he spoke about the dead.[1] The diminutive was to emphasise the incompleteness of transition because, for him, the dead were as yet something less than souls, and would become the latter only after the realisation of the project of universal resurrection. Amusingly, side by side with the niche of Venus Stockman there is a family stele of

the Dushechkins. (In Russian, *dushechka* is the diminutive of *dusha*, the soul.) Chekhov wrote a story *Dushechka* (which, incidentally, was much liked by Tolstoy). The heroine of this story, whose husbands by a strange coincidence of circumstances died one after another, could love only through permanent associations. Each consecutive image totally over-shadowed the preceding one in her consciousness. Being the wife of a vet, she could think and speak only about horses; when she married the owner of a firewood storehouse, only about forests, etc. In fact, she could live only by subtraction, subtracting the dead from the living. More exactly, since those living died at such short intervals, she was subtracting the dead from the dead in order to project an infinite soulfulness (*zadushevnost*) of blind interpretations. Within this theme, Dushechka, Chekhov's heroine, and Gogol's Chichikov, occupy the two poles of the Russian resurrection project. Dushechka was engaged in endless subtraction indicative of the 'absence of everything', while Chichikov dealt in endless addition, in a certain capitalist synthesis indicative of the total 'presence of everything', of all conceivable themes and opportunities. For everybody from Feodorov to the Conceptualists, Chichikov is the first curator of the Museum of Contemporary Art, while Dushechka is its first visitor. The story of Dushechka offers us another important epithet - the indicators of plastic absence tend to be not only clumsy, pitiful and unscrupulous but also anecdotal, for what can be more anecdotal than a typical 'ordinary spectator'?

The columbarium in its essence is a reduced model of the Museum of Contemporary Art. The ordinary observer sees the works on display as a reified emptiness labelled with the name of the author. He even walks there hanging his head in respect and just reading the labels. The comparison between museum and columbarium returns us to the ideas of Nicholas Feodorov whose project of resurrection was based on the concept of the Worldwide Museum of Ashes comprising the cemetery, the museum and the temple. Even on a lexical level, the concept of museum was always introduced by Feodorov into his list of cemeterial aphorisms: 'Each man bears a museum inside himself as a cadaver'; 'Higher than the museum is only the grave', and so on. Nevertheless, here we can distinguish two projects. One of them relates to subtraction and the annihilation of visuality, and is aimed at indicating horizons of uninterpreted absence. Let us call it the 'Project of Venus Stockman'. The second one, 'Feodorov's Project', on the contrary, is based on addition, on the applied summing up of all present interpretations, on each prearranged circumstance, on everything given to us in advance through superimposed narratives, and on all the things to which we are accustomed.

Feodorov was by profession a librarian who constantly worked with archives and catalogues, and was interested not in the contents of books but in their covers and titles. His attitude towards texts was similar to his attitude to the grave; only the book-cover was perceived, while every-thing else was just a rudimentary presence to be developed in the course of the Universal Project's realisation into a dazzling collective body suitable for reading – or not even for reading, but for an instantaneous, total understanding. 'Feodorov's Project' was a paranoiac addition where things were neither valuable or worthless, innocent or guilty. Feodorov dreamed of generations of librarians resurrecting their fathers who would become librarians in their turn and so on in reverse order till

the Day of Creation. First the adjustment, the rearrangement of book covers, then the museum showcases are broken open and the preservation of the ashes is combined with their resurrecting reprocession. When it comes directly to the method of resurrection, Feodorov's science degenerates into a banal, fanciful 'mad catalogue'. The librarians scatter cards and fight one another with catalogue boxes. The dubious attitude of Feodorov towards columbariums and cremation as a method of entombment in general is telling. It is evident that it is the columbarium and not the cemetery that represents an ideal museum as far as the ease and universality of cataloguing, labelling and exhibiting are concerned. On the other hand, the columbarium is also an antimuseum, because the process of keeping and preservation is preceded in it by cremation and annihilation. Paradoxically, the conditions of preservation are ideal here; but what is preserved is not the ashes and bones of the deceased, but their names, engraved on the tablets and merely marking - just as in the Museum of Contemporary Art – the emptiness behind them. For this reason, Feodorov hated crematoriums, considering them to be an offspring of industrial culture which neglected forefathers for the sake of procreation. Like any 'mad librarian', Feodorov was eager to drag into haughty Modernism not only himself but also rattling bones, coffins and skulls. At that time, however, it was not possible.

This Utopia has been realised, however, to some extent in the art of more recent decades through the amalgamation of empty variability and the immortal power and splendour of historic attributes such as church velvet, skulls framed in silver and grandiose bunches of artificial flowers. In the columbarium cells, space has lost its absent other-worldliness, and has been filled with hallucinatory visions. And what is more, memorial tablets are fitted with peep-holes so that one can view the luxury of magic imperishability, as has been demonstrated for the first time by Duchamp in his *Etant Donnes*. Instead of observing an empty interval,

Yury Leiderman, *The Pit and the Pendulum,* 1992 (detail), mixed media

we are forced to peep again and again at the versified eternity presented to us, as if in successive episodes of a detective serial. And somewhat mysteriously, side by side with the respectable figure of the 'elder' Feodorov, there appear young men in American sports-shoes. Among them we see Andy Warhol who collected 'everything', and the 'eternal' Keith Haring, and Jeff Koons, the producer of everlasting luxury. It is typical that the latter dreams of completely decorated spaces of unalternative presence of all versions and circumstances, among which denizens with blue blood exist beyond any argument in a state of permanent entropy. Feodorov, like them, also implied that resurrected generations after coming through death would turn into the shells of the new Mind, infinitely decoding and saving the Universe. Nowadays, the aim is to unify all versions so that there should be no innocent and no guilty in the spaces decorated by circumstances.

On the other hand, the *Project of Venus Stockman* manifests the passage through death with no accomplishments in the spirit of the 'shining creatures' (*à la* Koons or Castenada) and results merely in the disappearance of all decorations. At first the amalgamation of attributes produces pitiful properties and graphomania and then vanishes completely. All that remains is the interval indicative of the absence; for example, the interval 1904 (Denver) to 1936 (Moscow), implying the absence of Venus Stockman – or the interval of a visit to an exhibition when we glance at emptiness reified by the names of the contributors.

NOTES
1 Editors' note: Nicholas Feodorov was a Russian pre-Revolutionary philoso pher who believed among other things in the physical resurrection of bodies. He wanted to send them into space for preservation until a time when they could be resurrected, and he collaborated with Tsiolkovsky, the first rocket scientist, over this idea.

Yury Leiderman, *The Best and the Very Dubious*, 1992 (detail), mixed media

OLESIA TURKHINA & VIKTOR MAZIN

THE NEW DIS-ORDER SUMMARISED IN ST PETERSBURG

1 We are living in a situation of transition, of a vanished habitual order and strictly hierarchic cosmos which is being replaced by a situation that still has no name; for it is not just that one ideology loses ground to another, and one visual field or economic system is succeeded by its antipodes, but that a whole entity is giving way to a multitude of various phenomena. This multitude manifests itself as a result of the disintegration of horizontal territorial space and the acquisition of the temporal freedom to use different ideological and visual systems of heterogeneous chronological areas. Thus the present state of things cannot – in contrast with the past – be described in the structural terms of rigid temporal stabilisation.

2 This situation can, however, be described in terms of somnambulism, a state in which only the most archaic structures of the brain (the old brain of PD MacLean's reptile) and topographic regression make it possible for an individual to evade danger. At the same time, the succession of discursive orders in the course of the highest and most revolutionary – that is the least smooth – amplitudes is established by the chaotic mixing of fashions/codes (which coexist in rigidly stratified conditions when development is slow), prescribing ultra-short-term economic, aesthetic and so on, sanctions.

3 Resymbolisation permits the simultaneous vision of various stars, crosses and swastikas, so that the change of code realising itself in this country leads to the preservation of a stable psycho-pathological system when the basic concepts of existence are equipollently changed. Any dispatch to another semilogic order takes place with an equivalent change of emptied systematic taxones. Thus, the changing substances (linguistic deformations) do not upset their own parameters of the dichotic matrix of the functioning cerebral hemispheres.

4 Nevertheless, sometimes (and rather frequently, as in this case), the frequency of transition becomes disrupted, and there emerges a chaotic discursive formation of the second agraphic, which is connected with articulatory problems, order characterised by the following specific features: (a) an uncontrolled mixture of different linguistic paradigms which mutually destroy each other on losing transparency; (b) the attempt to insert an unknown and arbitrarily interpreted (in terms of the hermeneutic circle) ideomaterial into the permanently existing units of conscience. In fact, this phenomenon relates first of all to the concepts of the formation of a critical discourse.

5 The visible state of the post-Soviet order can be described not in terms of structural concepts when rigid stabilisation takes place in a definite time-span, but – owing to permanent temporal deformations – as the concept of multistaged temporal fracture, the stage of development of an extremely complex psycho-pathological situation characterised primarily by submergence into the depths of distress, depression and psychological confusion. And this directly corresponds to the develop-ment of creative processes, the therapeutic nature of which can,

Timur Novikov, *Salome with the Head of Oscar Wilde*, 1992, mixed media, collage, 200x120cm

however, remain unrealised, though the unexpected and maddening abundance of products of the sphere of visual consumption cannot be rejected as well.

6 The described situation of multiple geochronological fracture forms the self-deleting constellations which organise life according to the principles of unpredictable and unprognosticatory compositions (despite the emergence of thousands of prophets, shamans, parapsychologists *et al*), which allow us to speak about life as an art, about the definite and constantly changing landscape and about a texture within the fracture. Therefore, it is not surprising that life is considered more avant-garde and stronger than art in the programme of rewriting modernity (Jean-François Lyotard) which on the whole finds itself in the shadow of life; politicians and economists, maybe for the first time in the history of this country, forced out writers, not to mention artists, from its axiological hierarchy. The degree of variety and unpredictability in life is much higher than in art, and, perhaps more importantly, in life (if we distinguish it from art) the process of denomination and coding takes place faster than in art. That is, life in fact takes upon itself the function of art, thus realising the call of Lyotard: 'Away from the cultural ghetto!'

7 The visual sphere, that is the breach in the invisible, and the texture of the visualised contours and colours along with other systems of signs constitute a deformed and unreadable rebus. The sign-bearers of the language become converted in the rebus paradigm into actively interacting components of an open figurative sphere where the additional elements deprive the preassigned notions of their collective authorship which reflects the specific nature of geopolitical situation.

8 It is rather difficult to find the place of art among the rapidly changing urban toponomics, exchange rates, political and religious beliefs. On the one hand it has lost the Eden it had owned in the society of distribution, the Eden where no 'real value' could have existed at all. On the other hand, despite the functioning of the new economic model in society, art and culture in general have not so far approached the process of valorisation typical of a 'society of consumption'. The hypothetical equality at the face of the product of consumption applies exclusively to food and clothing.

9 The fact that art does not represent a real object of 'buying and selling' has a mixed effect on the sphere of aesthetic production in a society where the process of consumption has stunned the citizens with its novelty and scale. The history of St Petersburg has continuously been under the spell of its maladjustment to life. The alienation of art and life, of art and the audience and of art and the artist is conducive to the cultivation of a certain freedom of the 'artistic will'. It is true that the existing situation is far from realising the romantic myth of such a freedom. But in order to survive in conditions of the total absence of developed native industry and infrastructure in the sphere of visual redistribution, the artist, gallery-owner and art-dealer must avoid total submergence in the general context of contemporary art and its 'discourse'. Everybody needs some super-open structure of preconception, and probably a belief in the 'proto-language' and his own language of 'confused articulation' so appreciated by the Russian poets from Alexander Pushkin to Velemir Khlebnikov.

10 Proceeding from all this, the 'advantages' of the artist Sergey Bugaev (whose pseudonym is 'Afrika') can consist in his, to a certain

degree, minimum articism expressing itself in the fact that from the context of the economy of art/life he extracts 'prefabricated' fragments of the life's body and represents its code, the code of life itself, the texture of collective memory.

11 Nevertheless, while creating rebuses we observe just the opposite process, for the rebus encodes nothing, or to be more precise, decodes the collage, the fragments of narratives, the separate molecules but not the compounds, so to speak. The rebus is a prejudice in its own way, or according to Yury Lotman, a text with a missing code.

12 In absolutely different forms, the method of collage is one of the most typical of the aesthetic orientation of St Petersburg: as far as the last decade is concerned, it can be illustrated by the following examples: Timur Novikov, proceeding from Kuleshov's theory of the cinema, created the theory of recomposition in painting; the artist Vadim Ovchinnikov constructs collages of ethno-music; Oleg Konovalov collaged two feature films creating them from the scraps of movies from the 1920s and 1930s; Igor Verichev developed the concept of versification of information in music, which opened the way for a smooth seizure of the artistic scene by 'Acid House' music; Vladimir Tamrazov created a video-collage after Dziga Vertov; Afrika rearranges the montages of Rodchenko and Klutsis; Igor Riatov collages para-computer compositions of his photographs, toys and other rubbish. This list could be made much longer.

13 Let us return for the time being to the rebus. In the process of reading, in the attempt at understanding the rebus, there emerges a free assembling of words into context due to the dissociation of the code, and consequently the process of comprehension. This is how the rebus works – by the principle of contiguity and not of analogy. This situation is complicated, but maybe at the same time becomes easier owing to the systematic game of renomination (for example, Petersburg, Petrograd, Leningrad, St Petersburg . . .) Bearing in mind such a type of aphasia, we can say that the rebus is a metonymy. But taking into consideration the fact that the rebus demonstrates the process of renomination it can also be called methanomy.

14 Dissociation under the influence of ideological, social and economic factors results in the formation of an individual language. The transition of the language, the capture of morphological units and their re-formation, turn out to be nothing but the formation of a new language. Such a renovation and capitalisation of the language usually produces confusion, fear and subsequently various aphasic disorders.

15 One more phenomenon occurring in conditions of the fractural order consists of the reduplication and 'copying' of the process of dissociation in various spheres of human vital activity, particularly in the aesthetic field, where half a score of groups which formed the artistic scene of St Petersburg just a few years ago is replaced by a mere handful of prominent artists as a result of dissociation expected by nobody.

16 Correspondingly, collective responsibility is being replaced by individual responsibility.

17 The disruption of coding and/or decoding leads to the necessity to adapt the aphasic to a hostile, unreadable environment, his psychology becomes transcendental, establishing some outward Controller (God, CIA, KGB, UFO . . .) The transcendence as such is not coded, for it is isolated from any collective ritual. Thus, it is not art but the

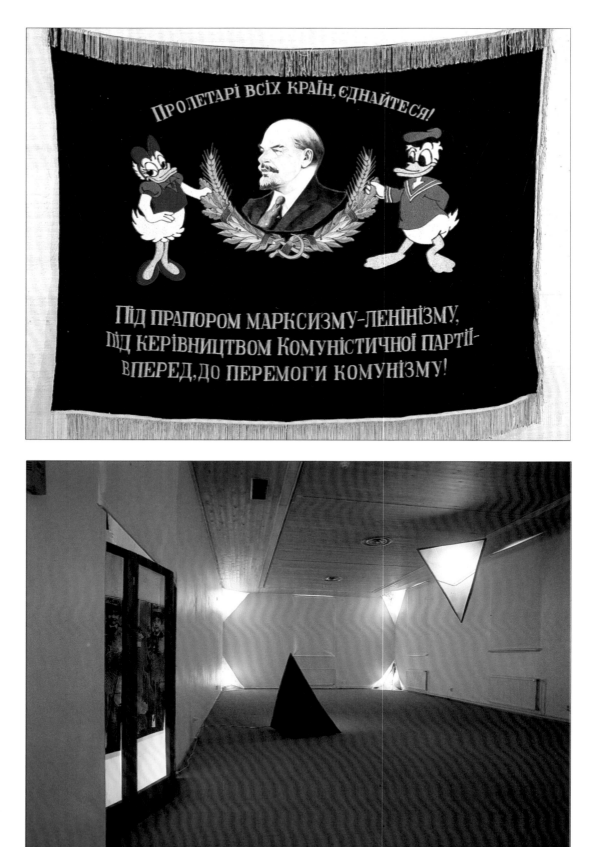

psychology of its producers that begins to gain explicit religious features. In this context, it is not surprising that a lot of artists of absolutely different aesthetic inclinations became religious fanatics. One of the former fathers of Necrorealism, Andrey Miortvyi has abandoned art, and at present is engaged only in the performance of religious rituals. The wild, well-known St Petersburg performance artist Yury Tsirkul, who always looked like someone with serious mental problems, is now absorbed in the study of treatises on the theory of perspective and research in theology in a monastery on the island of Valaam. Valerii Morozov substituted production of necrosculptures (wooden idols with the distorted face of his long-dead father) for prayers. Vladislav Gutsevich combines magical paintings with a scrupulous examination of the writings of the Fathers of the Church. Many artists turn to religious connotations indirectly: Andrey Khlobystin places his works into the corners and asserts that they acquire an iconic character due to their corner-position; Timur Novikov uses the iconic perspective, typical of old Russian icon painting (BV Raushenbakh); Oleg Maslov states that his anthropomorphic figures on pictures are icons; Michael Timopheev uses just a single iconic sign in his practice – that is, the cross; Afrika constructs his installation of 'numb' copper non-representative rebuses resembling the domes of Greek Orthodox cathedrals . . .

18 Though the reference to some definite source is clear enough in this or that case of artistic practice, asymbolism in the sphere of visual redistribution is evident. Thus, the wooden collages of Timur Novikov, the photo compositions and cinema films of the father of Necrorealism, Evgeny Iuphit, the works of Andrey Khlobystin and, naturally, the rebuses and flags of Afrika are perceived by the audience on a pre-semiotic level. All of them are the children of the 'nemovliat' (to make use here of Alexander Potebnia's concept) who are conducive to the suspension of semiosis, that is, to depression.

19 In such an asymbolic situation, there emerges a critical discourse aimed at the affirmation (V Tupitsyn), at the propaganda of a specific visual product. The situation becomes aggravated by critical parasitism of artistic speculations: such was the use of the territorial-historic programme of St Petersburg in the propagation (rather than in the abstracting or development) and legitimisation of Timur Novikov's Idea, which he labels 'Neoacademism'. Religious monoideology establishes the modernistic character of art, while the recoding of visual products into a critical discourse obtains the properties of an obsessive (mis)comprehension.

20 In the sphere of utilisation of the critical discourse, the active factor is what can be called 'Mental Express' by analogy with the 'American Express' system. By the use of a certain code, the writer attaches himself to a specific cultural context, and as far as the languages gets into the variable zone of chronological correlations (guiding and articulating them), it will always belong to the zone of fashion's influence/action. By exploiting the latter, the writer registers himself with a fixed but variable discursive group.

21 The boundaries of the language (= boundaries of the world) remain the same, and within these established limits there is the field of action of reflexed ideograms (already acting on the level of collective reflexes) in their native linguistic paradigm. These ideograms have the absorbed and digested (that is annihilated) elements of other discursive

OPPOSITE, FROM ABOVE: Afrika, *Untitled*, 1993, mixed media on flag, 139.7x154.9cm (Paul Judelson Arts, New York); Andrey Khlobystin, *The Corners*, 1993, mixed media/ coloured slides, part of the 'Method' exhibition, Museum of Pori, Finland; ABOVE: Afrika, *Untitled 'rebus'*, 1993, copper and acrylic on silicone plates, 90.17x90.17cm (Paul Judelson Arts, New York)

fields. Thus, the matrix of native conscience plays the role of the obligative parasite feeding at the expense of numerous donors (the latter usually perceived by ear as foreign parasites). The epistemological process of interiorisation of knowledge is realised by its transplantation to the existing linguistic patterns. The homogeneity of the linguistic organism survives, and the new alien formations, while preserving the appearance of presence, remain in a rejected and annihilated condition.

22 Differentiation of words and objects results in a complete departure from the objects, nevertheless the abstracting is not complete due to the false preservation of connotations with the objects of description. In this situation of aphasic juggling with concepts, there is no more place for real money – just for cheque books. It means that we are dealing with the second level of abstracting – instead of cash as the equivalent of the goods, we have cheque books as the equivalent of this equivalent. This is not the highest level of abstracting, but the high level of capitalisation which attracts the bearers of discursive-critical intentions. Knowledge of the code brings the capital which turns over in circulatory networks.

23 The exchange of the 'Mental Express' for capitalist goods works in favour of a well-regulated system with no visible sores and the last cavity in the process of healing, where the curse of this organism – the frontiers, murders, war, violence, racial intolerance – is just a specific mechanism of curing. The boils which once covered the body of Karl Marx now reappear as an echo on the skin of our state.

24 It is possible to single out several levels of critical speculation: the first level – the one of subspeculation, extensive agriculture in the field of thought, when the critics do not use grains-concepts, but a screen which allows them to speculate and to 'play thimble-rig' (a guessing game involving hiding marbles under a thimble). They do not facet the screen but play the role of the thimble into which marbles are driven. The next level of speculation is reached by the principle of the 'Mental Library Express', and the users of the 'Mental Express' are of a relatively high order for they construct a complete abstract system of Hegel's type. The other level – but by no means a higher one – relates to the use of the 'Mental Express' for the formation of schizophrenic chains (described in particular by Gilles Deleuze and Francois Guattari) in the system of interrelations between the two signs (and not between the sign and the bank-note which is typical of mental-clerks of the lower order – though it is clear that the situation cannot be idealised and that both exchanges can take place simultaneously).

25 In the given situation, the use of the schizophrenia/paranoia opposition must be not only cautious but also critical – not in the last instance due to the fact that the first member of the pair is viewed in the critical discourse as something beneficial, as a dominant in itself, with no emphasis placed either on psychological processes typical of schizophrenia or on paranoid aspects of productivity, but also with no attempts at determining the character of schizophrenia and with no understanding of heterogeneity implicit in schizophrenia as such.

26 Besides, it is necessary to take into consideration the nozological systematics – for example, Melanie Klein – when schizophrenia together with paranoia are in opposition to manic-depressive psychosis which is of the same interest for the researcher of aesthetic processes of psychics (eg for A Erenzweig).

27 When using the psychopathological discourse, it is also possible to include epilepsy in the same aesthetic paradigm, for epilepsy relates to (MacLean's) idea of the processes of expansion of the central nervous system which take place most explicitly during the formation of the psychosensorial aura. More than that, epilepsy, ie the seizure, etymologically relates not only to gnosis but also to the links connecting the activity of the brain (conceptualisation, criticism, speculation) and the hand (production of artefacts, works of art etc), which is divided from the paw by the gulf of speech and thought (Jacques Derrida); therefore the disruption of the activity of the hand must involve certain aphasic processes.

28 Capitalisation in the operating conditions of 'Knowledge is Power' manifests itself as a continuous series of punctures perceived (or not perceived) as the tricks of temptation. Advertising and visual arts in general oversaturate the sphere of images, causing an optical poisoning, especially in a situation of rising interest and no immunity. The tricks of temptation disorient the individual and he decreases the rate of his perception either by addressing the Idea (first of all the Idea of Growth – the Capitalist Idea and the rest of the Big Narratives of Lyotard), or by suspending rather than transcending the semiosis, including it in the depression. Capitalisation of knowledge relates to the desire to increase the speed of coding/decoding which requires continuous introduction of new passwords (Lyotard), hence the object of transcendence gets lost with the result that the depressive state becomes aggravated.

29 This state inherent in the existing socio-economic sphere and its aesthetic counterpart is determined through the 'Loss of the Thing', through Something that escapes labelling (Kristev), through the longing for something lost, something missing.

30 In his turn, the artist can show the disappearing substance or at least can somehow express this intention in the finalising effect.

31 This intention manifests itself particularly in the obsessive desire to subject the rebus to reading; thus we find ourselves face to face with the processes taking place between so-to-speak conscious (visible and used visually) and unconscious (repulsed) sections of the sphere of visual images. The rebus, like the dream, represents Things and the Puzzle, that is the loss and impossibility of finding it. The rebus is rather 'multithingal' than verbose: the reified words situated one under-, over-, before- and after- another constitute an avalanche of words in which we have to discern the missing forms. Some of Afrika's rebuses partly repeat the 'original' rebuses transferred to the copper printed circuit boards from the album of an anonymous artist of the 1950s or from the 1947 book *Targets of Literature*, or from an entertaining book for children published in 1948. Thus, there emerges a metarebus: firstly, because it demonstrates the principle of work of all rebuses; secondly because inside it the reuse of a specific system of signs takes place. If the reading of the 'original' rebus poses some difficulties owing to the conventional rebus symbolics, lexics of the 1950s and the nature of the ideological model of that time, Afrika's metarebus is not amenable to monosemantic reading. His rebuses represent the succession of losses and overlays, the former increasing the latter, while the latter in their turn cause yet more losses. Clarification of essence in Afrika's rebuses is gradual and unpredictable. And it is never complete. Coding and decoding, in distinction to 'real' rebuses, are not interrelated. The solution is not pre-set in the form of a text; and the principle of algebraization of day-to-day speech, some-

times brought to the limits of the understandable, is not amenable to decoding, for in the metarebus the essential part of the message can be lost in the process of self-reduplication. What happens is the mutual superpositioning of the codes, as a result of which only the material selection of different non-signified codes can be read. Afrika's rebus is anti-cognition.

32 Reduplication and mutual superpositioning of the sensitive fields are also observed in Afrika's other genre of work – his flags – which represent elements of statehood identification superimposed by sewed-on elements identical at the level of expression (of the material) but symbolising a different cultural code: a different power, the world of micro-organisms, the world of childhood, religion etc. Such a sewing-on (superimposition) remodels the flag, esemioticalises it and hides/half retrieves the lost. Such a methodology enables Afrika to exist within the 'limits' of the obsessive representation syndrome. The latter was coupled with the dissociation processes taking place in the country and the loss of the former field of signs; as a consequence the artist continues his work but as the inmate of a mental home.

33 The departure into the world of childhood and narcissism takes place in the dark corners of Andrey Khlobystin. The loss of mother provokes the infantile orphan into looking for a substitute. Left in the darkness he plays 'Fort-Da', discarding his skates and skis in the corner, sheltering himself from the world behind a screen on which he builds his mysteriously archaic relationship with animals in which a child understands the language of a kitten; framing himself with soft pillows with the regressive portraits of the artist's family members. These 'dusty corners of childhood', large colour slides photographed in the 'real' room corners and placed in the lower and upper corners of the room, demonstrate the work of memory in producing hallucinations and dreams transforming various cross-sections of consciousness.

34 The child left by adults alone in a dark room feels a mystical horror of and interest in life he cannot see. Billions of micro-organisms obtain their/someone else's face; each cell considers itself a person (Morin). Paradoxicality of the unexpected autonomy becomes Fatherlessness=Lawlessness=Anarchy. The citizens of once one of the most hermetic formations (which had an outlet only into the schizophrenically asthenic upwardness of Open Space – from Closed Space), ie the Union of Soviet Socialist Republics, become citizens of the universe which equals the loss of citizenship.

35 Which leads to the emergence of artificial fences, screens, translucent surfaces at least partly covering the space of claustrophobia – the screen (for example that of Khlobystin or Afrika).

36 At the moment of change of power – in the interregnum – anthropology or rather anthropo-morphology of power manifests itself most clearly. The individual temporarily released from any new regulations feels keenly the former biological correlation between his body and a specific way of ruling the state. These conditioned and conditioning bonds between metapower and power relations introducing the body particularly into the sphere of sexual relations were demonstrated by Soviet society with great clarity at the beginning and end of its existence.

37 Hand in hand with the destruction of traditional 'power/individual' relations comes the gradual change of the formally proclaimed relations between the sexes. Strong political and social processes correct

Evgeny Iuphit, stills from the motion picture
Father, Santa Claus has Died, 1991

sexual deformations and are corrected by them. The bipolar model – aggression/submission, conflict/mutual understanding, identification/de-identification – describing relations between individuals and between man and woman in particular, transcends to the level of relations between nations. For some time, the collective personifies the properties of the individual (Vladimir Bekhterev), though in the crowd all instincts manifest themselves much more strongly including the sexual one. Sexual aggression correlates with social aggression, while the conflict with the ego (alien ego) does so with ethnic conflicts. (The interdependence of aggressive and sexual manifestations of the collective was established in particular by the example of the adjacent habitation of people and a herd of orangutangs, whose sexual cries decreased the aggressiveness of the human group.) The collective is a collective personality, and the laws determining manifestations of the collective's activity are in principle similar to those determining manifestations of the individual's activity, while the social instinct is more important for the development of society than the sexual one (Bekhterev).

38 Nevertheless, the sexual instinct remains to a large extent extremely important in the sphere of production of visual images and first of all in the field of ideas related to religion, which can apparently be explained by the 'essential closeness of religious and sexual matters' (Vasily Rozanov).

39 Timur Novikov is a specific 'penetrator' into the feminine discourse where he operates in the genre of stories which he cultivates. In these stories he shifts the socially imposed regulations concerning the role of the gender. His favourite story is that of Nadia Leger who transported weapons for the French Resistance during World War II using a pram for the purpose.

40 In the horizontal ecological work *Oil spill in the Persian Gulf* (white ships floating on a sea of black rubber), Timur Novikov demonstrates the conditional character of spatial opposition. The horizontal in the male/female pair relates to the feminine element, while the vertical has a stable symbolic male meaning. The horizontal is natural and fertile; the horizontal position is fixed in European culture as the symbol of two sacral moments in human life – the moment of copulation (with the earth) and the moment of death. The *oeuvre* is spread on the floor and can be observed either from above (from the heavens) or from beneath after taking the same horizontal position. In any case, the potential observer experiences the shift in his habitual ideas of the top/bottom, front/rear and horizontal/vertical, included in the general 'male/female' dichotomy. Novikov's strategy, aimed at an escape from rigid sexual identification, manifests itself in the emphatic way he exhibits his works over the bed; the observer has to be satisfied with a passive sexual role regardless of his/her sexual identification.

41 In July 1990, Afrika and the Moscow artist Sergey Anufriev penetrated the door placed at the vaginal opening of the figure of a woman from a collective farm, the female half of the famous sculptural couple *A Worker and Woman Member of a Collective Farm* by Vera Mukhina. As a result, the door which had secured the entrance into the woman was stolen, to become a pendulum in Afrika's installation *Donaldestruction*. The initiating magic of this act is clear, for the door covering the vaginal opening is none other than the clitoris. The female member of a collective farm, ie the earth, lost her androgyny owing to

OLESIA TURKHINA AND VIKTOR MAZIN

clitoridectomy, and irreversibly became a woman, while the clitoris separated from her is driven mechanically up and down against a background of ideological altars of the two superpowers – America and the USSR. (In Dogon mythology, the clitoris hindered the first copulation of the god Amma with the woman, Earth, created by him. It was a termite hill which rose at the approach of the god, thus demonstrating its masculine strength and blocking the entrance into the womb, ie, the termite nest. Therefore, Amma cut off the termite hill and had sexual intercourse with Earth.) Afrika completed sexual identification of the Collective Farm Member-Woman-Earth and even Russia, who consequently produced an 'agent', or strictly speaking the agent 'fell out' of Her. Hence the immensely long clitores of the two Arnemland sister-primogenitors which dragged about the ground and hindered the exit from their permanently pregnant wombs, keeping the babies inside. The agent is unsexed in principle; his sex is neither male nor female; it is is ideology. Devoid of her masculine power, Russia can no longer keep the 'agent' and 'drops' him into the world as seeds are dropped in the field.

42 The basic character of ideology and the agent-hermetic character of representation of this ideology ('Secret Cult') in the sphere of redistribution of images forms and formulates the proto-antique and neo-classical intentions of Timur Novikov. The declared departure from contemporary aesthetic 'achievements' – according to the Idea – introduces Novikov's art into the action zone of Post-Modernism's parameters; but at the same time this art (or to be more precise the very idea of this neo-academic art) takes his problematics away from a time of rewriting to a time outside time, to the religious-modernistic dogmas of eternity, to the termination of capitalist growth, to ennui and melancholy in the face of the approaching Ideal which cannot be approached.

43 The reanimator of the 'Secret Cult' (antiquity and the plot in the dominance of the avant-garde) in the new 'reformed' ('reanimated') St Petersburg, Novikov has produced a series of works on textiles and photo-collages: *The Life and Amazing Adventures of Oscar Wilde*. In accordance with the oriental tastes of the hero and his love of the Hellenic-Roman world, the artist has placed him on silk fields of Chinese shawls embroidered with flowers and landscapes, adorned with Roman sculptures and ancient ruins. Thus, *The Trial of Oscar Wilde* takes place in a theatre full of classical reliefs. And the protagonist of his drama, Salome, personifying one of the Danaides, is positioned within the Chinese landscape holding the head of Wilde, placed in a bottomless vessel. Each work is a narrative, its narrativity relating to the content of original images. Both technologically and thematically, Novikov's works follow the oldest principle of multi-layer narrative. The figure of Oscar Wilde appears not only in connection with a definite psycho-sexual orientation (as is always the first thing to be noticed), but also because of the transplanting of the critic from the field of description into that of production of works of art (art proper), which is of equal importance, particularly for the ideologist Novikov, who has brought off this coup.

44 The dead body is desexualised and deideologised.

45 This assumption proves true – is it possible? – from the point of view of the dead body itself: it is situated outside ideology, though this does not mean that ideology has no interest – including a sexual one – in the dead. The dead body can provoke not only religio-erotic ecstasy, but can also be the sacral centre of cosmic ideology.

Vladimir Kustov, *The Electricians*, 1991, oil on canvas, 100x70cm

46 Devoid of man (conscience), the man (his alien Ego) is 'placed' at the base of the aesthetics of Necrorealism, the diversified artistic movement which is represented – after the dissociation of the collective body – by the individual practice of three artists: Evgeny Iuphit, Vladimir Kustov and Sergey Serp. In the art of Necrorealism – inculcating, hiding the bad/good form of representation – there is no figure of Death, while the Case of Death allures the artist to the utmost extent.

47 The allurement by Death is especially 'successfully' carried out in St Petersburg, the city of apocalyptic prophecies, suicides, art, mental patients and dead beauty.

48 The pact with the alluring subject results neither in necrophilia nor in necrophobia. Necrorealism is the wish to avoid both the former and the latter while rejecting the symbolic perusal of reality (depiction of death in the epoch of the Renaissance) including the reality of death (the death of death through the ellipse of art).

49 Death is determined by its relation with consciousness not as loss in the pass but as loss from the future, while the lost, that is the former (once alive, out-lived) Thing (its 'substitute' is Freud's coil or a work of art) constitutes – at the border of consciousness – the state of melancholy and 'unmotivated' depression, the reason for which is not realised, the state followed by the desensitisation (of the sense) of life and the feeling of the imminent arrival of death.

50 One of the postulates of Necrorealism's aesthetics (especially typical of its early period, when lots of artists took part in the movement) is the demonstration of unmotivated actions, the regression of which from the realm of consciousness is aimed at approaching the Loss, the Thing, the Body. The dissatisfaction of *Homo Sapiens* with Necrorealism leads to the conscious quest, conscious depiction of the non (sub)-human: anthropomorphic forms are changed for zoomorphic, posthu-

The 'Geopolitics' exhibition, 1991, the Russian Museum of Ethnography, St Petersburg, foreground: Timur Novikov, *Oil Spill in the Persian Gulf*, 1991, black rubber film, toys.

mous transformations of the body become visual. Thus Necrorealism turns from man to un-man, to the alter ego of man as such – to (his) animal, (his) cadaver, (his) body.

51 The art of Necrorealism (the very concept points to the reconciliation of the dead with living matters) is presented as art *par excellence*, for it establishes two-way communication with the bygone: firstly, as art always symbolising and doubling reality (external/internal) and closing the gap between the subject and its environment; and secondly, as art which has chosen the dead body as a subject of narration (the dead body represents, in fact, the identity of singular subjectiveness). Such a doubling of the double (of death/art) can be considered a mechanism for the departure from a state of depression 'activated' by the loss of the lost subject.

52 The departure from 'normal' functioning of the human being into the Kingdom of the Dead, the Kingdom of the Lunatics, the Kingdom of the Animals and the Kingdom of Mushrooms results in the disorganisation of order, in reorganising the latter into a new disorder, which, as if in contradiction to what has been said, turns out to be the fundamental characteristic of man who spends most of his life sleeping. Also it happens because of the encroachment of disorder caused by dreams, and by dreams invading life (Moren). And the ritual of art regressing to magic, which envelops – often outside the field of production of objects for visual consumption – the activity of St Petersburg artists, manifests the reaction to disorder.

53 Because everybody remembers the Russian saying: 'Great orders entail great disorder'.

St Petersburg, December 1993

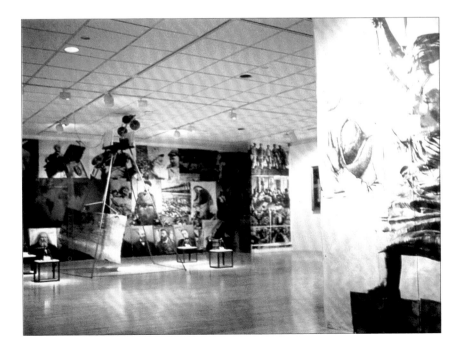

Afrika (Sergey Bugaev), *Donaldestruction*, 1991, installation, mixed media. In the foreground can be seen an image of the *Woman Member of a Collective Farm*, from Vera Mukhina's famous sculpture

OLGA YUSHKOVA

SHAMAN ART
Engel Iskhakov

Engel Iskhakov, half-Tartar and half-Uigur, came to Moscow from Ufa, the capital of Bashkortostan, in the early 1950s. He entered the Surikov Institute art school and after spending a decade in Moscow he graduated in 1962. His education started in the period of Stalinist 'Applause' art and was concluded as forefront art came into the hands of those who created the so-called 'Stern' or 'Severe' style. Those adept in this style were eager to reflect the atmosphere of Khrushchev's 'thaw' in their works. It is precisely this group of artists who are associated with the first changes on the battlefield of Socialist Realism. They addressed the theme of the severe daily labour of *homo sovieticus* and did not treat it as a moveable feast, which had been the trademark of the preceding era. Simultaneously, they began to depart from the venerated dogmas of Russian realism of the nineteenth century and made a timid attempt to use some alternative approaches such as Primitivism, the vestiges of Soviet art of the 1920s, and so forth. And it was in the early 1960s that Moscow's Bohemia produced from its midst a small but noisy and varied breed of artists and writers to be known as the Moscow underground, who took up the unsafe but nevertheless attractive position of unofficial art. This milieu was permeated by the aura of discovery – the discovery of Western twentieth-century culture; and hence, submerged in it.

All this was absolutely clear to Iskhakov, but he was suspicious of both trends and preferred to leave Moscow for Central Asia. He settled in Tashkent (the Uzbek capital), where he has been living ever since. The choice was logical for him, for he understood that the 'thaw' could not melt the basic principles by which the socialist system was operated. Hence, he distanced himself from the heartland of the empire and settled in the realms where the authorities were as vigilant as they were in the centre, but were far more naive about questions of culture. He went not only as far as he could, but to the east, to his birthplace of a kind (the Uigurs are one of the ancient peoples of China, some of whom migrated to Central Asia). Iskhakov became a participant in official artistic life, earned his living as a graphic and book illustrator, and pored over the concept he had been working on for several decades.

Engel Iskhakov was taking a great risk when he named his artistic system 'Shaman art', for he could easily have been misunderstood. Everything relating to the concept of 'shamanism' in modern society is prone to ambiguity (from the activity of paranormal personalities to its scientific interpretation), and also because to use the name 'Shaman art' is pretentious. The word 'shaman' suggests that here we are dealing with just another variant of a Post-Modernistic construction known as 'Archaic Constructivism', while the second word, 'art', is inevitably associated with the names of the majority of trends in art of the second half of the twentieth century.

What is the essence of 'Shaman art' and on what plane does the artist conduct his quest?

As early as his student years, Iskhakov knew about the Russian avant-garde in detail, and selected Kasimir Malevich as his guiding spirit. It was also at this time that he developed an interest in ancient cultures and various systems of signs and hieroglyphics. His fascination with antiquity is explained by Iskhakov as follows:

... we are torn in time, and it is practically impossible to create a complete picture of the system 'Man-Universe'. Antiquity presents now and will always present a large amount of material for the future, and will even form a base for space civilisation. As early as the Neolithic Age, man began to understand the basic key to the code (the signs of the Universe), and these keys are again becoming absolutely necessary today in the solution of global problems.[1]

Once he had become absorbed in these problems, Iskhakov embarked on formulating the concept of 'Shaman art', comprising three interrelated elements: (a) SPHINX-SHAMAN – spiritual concept; (b) Ideo-SPHINX – the system of signs; (c) Shaman art – the work of art as such.

The theme of Iskhakov's works is the movement of ideas in the space of human civilisation. Organically, he comes to use the artistic language of the sign. On the one hand, his search is based on Suprematism; on the other, on sign systems and their elements in ancient cultures. Nevertheless, he is far from simply copying them. On the basis of the established structural notions of the Universe, the artist creates a table of his own signs, the purpose of which is to determine and transmit the coded information on the Macrocosm. This table finalises the artist's theoretical studies and forms the foundations of 'Shaman art' as its system of signs. According to its author, it represents a 'visual language, the elements of which are based on pictography and ideography, where plastics play an important part . . . '

Within this system, the signs are oriented within the limits of a pictogram; that is, within the limits of relative recognition or maximum generalisation which holds true so that the sign-symbol preserves some structural link with reality without being transformed into a hieroglyph, or a phonetic sign.

The signs are based on the following key elements:

 The direct line and arch; the direct line is the male element, the arch is the female one.

 Eight co-ordinate positions of the two key elements.

On this basis, the initial ideas (postulates) are formed:

| Vertical line

— Horizontal line

+ Cross

The system is based on the simple initial graphemes which have initial interpretations; they become more complex with the complication of the theme:

SCORPION
Scorpio; Fire; Magic; Mystery; Providence; Foreknowledge; Spirit; Cognition; Nobility; Fury; Silence; Madness; Pharaoh; Incantation of the universe.

WINGS
Wings; Flight; Flame; Imagination; Wings-Flame.

ARCH
Arch; Boat; Vessel; Sky; Fate; Fate-Route; History; Movement; Travel; Shift; Nomad Encampment.

TEMPLE
Temple; House; Yurta; Family Life; Being; Existence; Protection; Edifice; Nest; Structure; Destiny-Life; Personal.

BIRD-BOW
Bird-Bow; Bow; Arrow; Bird; Dove; Air; Wind; Letter; Spring; Morning; Thunder-Bird; Movement; News; Flight; Breeze; Aura; Zephyr; Flow; Wind-Flow.

Thus the system of signs represents a laboratory of the artist, who is engaged in the quest for forms which can manifest the concepts from the realm 'Man-Universe' and synthesise the human idea of the Macrocosm. Iskhakov is very serious about his work, endowing it with mystical undertones. He works only in a state of ecstasy which he attains by different means – for example, by sitting in the midday sun of Central Asia. He defines his work-process as 'structural trance', explaining this term as follows: 'The Ideo-SPHINX system of signs is based on the idea of the essence of the image, its frame and structure. Therefore, the concept of "structural trance" means "transcendental creativity based on essences".'

The final result of such a process is the creation of a work where the sign is transformed to become not a bearer of information/messages but a bearer of an artistic image; for example, an element of artistic form. In other words, the author not only searches for the means of expression of the coded concepts of the Universe, but also tries to return to fine art and what it lost in the twentieth century: the concept of a universal code. This universal code forms the basis of any prominent style in art.

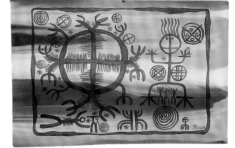

The plastic language of Shaman art contains elements of traditional archetypes together with certain newly discovered modes of artistic influence. Modern art has witnessed numerous peculiar attempts at introducing the sign to correlate the essence and the concept. As far as this background is concerned, it seems especially important that the artist uses the sign as not just one of the composition's elements, but as its main, and in fact, sole component.

Engel Iskhakov presumes that his system of signs is 'the project/ hypothesis of an international visual plastic philosophico-poetic language', and that his work is a breakthrough from antiquity into modernity and the twenty-first century: 'It is one of the spiritual manifestations of Time, when the unity of the times and the unity of everything human is established through the personal work of the artist'.

How typical he is! Iskhakov seems to be an exemplary representative of Russian culture, always preoccupied with the problems of mankind.
 At the same time, he is a typical representative of Oriental culture, full of characteristic cosmogenic feelings, perceiving the world as an entity where the bird, the tree and man have a place of their own; the culture renowned for its sense of improvisation, for everything in this world exists everywhere and in everything, a culture which is able to think in images and not in words.

This complexity of perception, typical of Iskhakov, results from the amalgamation of various artistic traditions which have existed throughout the history of Soviet art. Starting in the mid-1960s (incidentally the same time as the artist's career took off), the problem of ethnic traditions once again became acute in Soviet fine arts. During the last three decades it has been simply turning towards a deeper realisation of the ethnic cultural code, focusing on the history of the nation in the context of the world's past. Thus, the representatives of the eastern regions began to see themselves as bearers of Oriental culture, whereas those of the western territories related to western culture. In parallel with this process, artists became increasingly engaged in the contemporary developments in European and American arts, as far as their quest for identity was concerned. In this context, Engel Iskhakov is an extremely interesting figure. His work places him on the crossroads of various artistic traditions, while many of his methods as well as his simultaneous orientation towards history and the avant-garde are typical of postmodern culture. Similarly typical is the coded character of his stylistics: the artist combines elements of Neolithic culture, ancient and medieval art, and while remaining the heir of the early avant-garde makes an inevitable correction: 'As Malevich once said . . . '

1 Here and *passim* the quotations are from the unpublished manuscripts of Engel Ishkhakov.
2 SPHINX - abbreviation of the concept 'synthesis of philosophy, art, science, computer, word'.
3 Ideo-SPHINX - ideogram of SPHINX.

Engle Iskhakov, *Cosmos of the Shaman*, 1986, graphics, paper, watercolour, brush, 65x80cm

EVGENY SEMYONOV
TWO EXHIBITIONS

The development of the artistic process in Russia has its own unique and specific features. Contemporary art came to life here only quite recently, when the necessity to struggle against anything or anybody disappeared and was replaced by the feeling that the artist was free at last to partake on an equal level in the artistic life of the world, and that the cage of underground activity had been finally demolished. The first semi-legal exhibitions, which took place in 'Kashirka Hall' in 1986-87, heralded not only the end of Sots art, of unofficial art in general, but also the emergence of a new artistic environment. As far as my personal work in the field of what is known as modern art is concerned, those years were the first stage. Nevertheless our conscience, formed under decades of social pressure, was prone through mere inertia to the recurrence of underground activity. Aggressiveness and the tendency to expansion typical of such a type of conscience, manifest themselves in the creation of 'clandestine cells' – the practice which is unfortunately alive even today.

Interest in the research of anonymous sources in art is likely to be organic at the first stage of departure from the underground. Bearing in mind the framework of the situation which existed at that time, our exhibition at the Stuart Lexy Gallery in New York looked like a logical initiative. The impulse for this exhibition was given by the accidental discovery of a little watercolour signed with the initials 'AB'. The picture portrayed a boy admiring a mushroom he had just picked. This work resembled an illustration in a children's book from a former age. Twenty more pictures were painted so as to continue the life of the anonymous author. Characters included the meter-man; Samuel Lloyd, the inventor of the game of '15'; the inhabitant of the capital who brought interesting news; the conjuror with a performing dog and a prompt-box; and all were intended to represent the inner state of our mind. These meditations over the conditional character of the environment and all its components culminated in the picture *Clandestine Correspondence of Conspirators*. The composition is divided into two, thus bringing into balance the grim and shadowy world of the underground and the sunny world of the police with all the ephemerity and subjectiveness of both.

Like many others, I spent a lot of time working abroad, losing touch with the reality of our domestic artistic process. Meanwhile, substantial changes took place both in the situation in Russia in general and in my mentality. The crumbling 'underground' conscience was penetrated by confusion which resulted in the emergence of self-defence, demanding a more respectful attitude to the artist's true personal tastes and inclinations. Thus the basis for a positive artistic practice was founded. The final departure from formalistic tendencies took shape, while the interest in history and cultural heritage as applied to art was on the rise. The urge to participate in 'clandestine cells' aimed at expansion became weaker, and was replaced by the temptation to be submerged in the Borgesian quiet of libraries. Personality-oriented trends in art suddenly became

attractive. Overcoming the feeling of timidity in our arguments about good taste, we simply gave an answer to the question of what is right and what is wrong, thus determining the subject of research.

While we were preparing an exhibition of Michael Ksenofontovich Sokolov's miniatures, we decided not to hide our admiration for this artist. In 1931, although he had been interned in a prison camp, Sokolov continued his artistic work in secret, using any kind of makeshift material which came to hand. On matchboxes, rice-paper and scraps of letters, he created the most amazing romantic images. These tiny pictures were put into envelopes and sent to friends and relations.

We began our career as art historians by finding the children, grandchildren and acquaintances of Sokolov. It turned out that their private collections included hundreds of miniatures sent from the camps many years ago by the artist. The key to the future exhibition suddenly became a simple thought: that the often involuntary choice of the means of self-manifestation inevitably must produce in the artist an amorphous complex of size. We decided to carry out an artistic 'surgery' of a kind, to release the artist if only posthumously from this malady. For such a psychoanalytic action we selected five miniatures reflecting the major trend in the work of MK Sokolov during that period. For each of the paintings a special plastic and rhythmical solution was developed. It also looked interesting and new to exhibit simultaneously both modern and post-modern works created on the basis of his pictures. This emphasised not only the historic affinity of the former and the latter, but also the continuity between them and, in my opinion, symbolised the concreteness of artistic reality.

As far as I see it, a new historic time is coming, and soon there will be a new artistic space. What will it be? Everything depends on us.

LEFT: Semyonov & Jute, *The Summer of '38*, 1990, oil on canvas, 120x95cm; ABOVE: Semyonov & Jute, *Clandestine Correspondence of Conspirators*, 1991, oil on canvas, 124x240cm

100

NATALYA KAMENETSKAYA
RE-ANIMATING CULTURE
St Sebastian

The image of St Sebastian in Christian iconography is perhaps one of the most complex. This article examines its assumption of almost universal dimensions: sign-symbol, acting extra and romantic lover on the stage of European Christian culture; victim, canonised and admired in its own time, counting down apocalyptic cycles from the birth of Christ. Now, almost at the end of the second millennium of our era, we propose the following hypothesis: that in the contemporary picture of the world, the favourite child of God – the human being – finds himself in a situation which helps him to identify with the image of St Sebastian. Thus, the tale of St Sebastian is also a description of the mentality of a man facing not only the end of a century, but the end of a millennium as well.

The real St Sebastian was a Roman officer, a Christian and a mystic. He was castigated and executed; in his 'first' life he went through the long and tortuous ordeal of dying twice – by arrows and by stones. He was given to Time for his next life – as image-object, as an example of the proper relations of the victim with the crowd. Sebastian was canonised and became very popular in the next historic cycle, the Renaissance.

Time is a very real issue both for us and for St Sebastian, since now is his time. Entering this delicate and intangible area, it should be emphasised that 'Time' for the purpose of this article is not a given tangible (it never was so). Time is a cultural category and for its existence it needs creation and confirmation. In order to function, it may often be interpreted in the following way: 'It is not enough that it exists and it will be because it was'. Time is contained and exists in various sign systems, both simple and complex. Like any cultural product it thinks, to be reflected structurally and graphically.

It possesses the qualities of cyclicity, inevitability and eternity (round mystical dial); dynamics, dialectics (spirals); creativity (waves); past, present and future (line).

Time possesses a gamut of emotional images:

1 History – the unbiased and objective judge.

2 Justice – the past is not infinite, it is judged by the future.

3 Time – the manipulator. By creating a universal system of thoroughly tested codes (symbols, signs, names) it tests itself on humans, turning them into their own objects. It is not at all paradoxical then that the guardian, interpreter and finally the subject of this manipulator – Time – is essentially human.

The structure of this amazing 'human' at this real moment has received many additional meanings due to the theoretical inchoateness of the world map which has no place for a human. It all falls into a multitude of elements, where each one interprets the world as a separate subject.

Time became open to development by further cultural categories (space, for example) and also the 'time machine', a unique moment of coincidence, a simultaneous experience of different time positions

Natalya Kamenetskya, *Untitled*, 1993, computer graphic

coming together. An important apparatus for distinguishing, which is an emotional factor of the human mind, could be helpful except that it too has been modelled by culture and put into memory (and as a result we get our answers as programmed reactions).

A similar state of consciousness is not unexpected. The 'complex' human soul on all its levels, the biological one included, responds to certain time codes: the end of a century, the beginning of a new century and now the meeting of two millennia.

4 Time is emotional and erotic (life and death). This allusion brings me back to St Sebastian and his romance with Time.

5 The unfading face of Time (St Sebastian).

So, a broken phrase: 'Within the next time-cycle (the Renaissance), St Sebastian was finally assimilated by the canonical European mind as a kind of allowed and pleasing sacrifice to God, the unique object for sadomasochistic violence'.

The path of sacrifice goes back to dark archaic times, but in more recent years was improved upon by European civilisation with its Christian symbols. To make a man a sacrifice is now regarded as inhumane. An object of a third way is chosen now – not man but a son (of God and of man), a sacrifice and a resurrection, not complete man but not woman: St Sebastian. For some period he was the only saint whom patriarchal religion allowed to be pictured naked. He is always of a feminine demeanour, pierced by arrows, dead and yet beautiful and tempting. (There is a story about a woman who requested that his picture be removed from the church because she was erotically aroused by it.) During epidemics, St Sebastian was thought to be a protection from plague – resurrection for a future sacrificing.[1]

The body had always been an object of ritual sacrifice. For culture the body is also the subject of speculation within the traditional system of binary oppositions (Man-Woman). By addressing a third, indefinite sign of St Sebastian, culture sacrificed the body itself: 'Death of St Sebastian'. His death and hence his life are relative. He has the image of an immortal soul. Image is bodiless. An image is the ideal partner for a necrophile – part of a culture which feeds on the past.

The end of the century is a conditional end of Time. This is a return to near-birth memories, a set of experiences around the birth moment, a twisting of consciousness on the edge of life and death. Such a condition is full of anxiety, aggression and fear. Sometimes society becomes a crowd possessed by suicidal madness, attempting to kill itself and Time, calling for chaos. In a moment of chaos man tends to forget that he has no power over his life and that since time out of mind he has been a pattern, an object of manipulation, part of a universal system which is managed by means of codes.

For the system created by the given type of culture, image is the model of a human. According to the image, all levels of human consciousness are coded (including the subconscious, unconscious etc). Even consciousness considers itself conditional. Its emotional component listens agreeably, reacts properly and creates its own, already cultural image – but this time on a living being. The artist becomes a painting and even becomes one of the characters. The subject of creativity becomes a victim – even the system itself goes through crisis – yet another end of millennium.

One can give an order and annihilate the system and then create

another. One becomes not the victimised object but a subject of third orientation. The end of the twentieth century is sincere and gregarious. It possesses an intricate and colossal communication system and culture becomes available to the masses even in its most esoteric manifestations. We recognise St Sebastian on the pages of pornographic magazines from different parts of the world – stoutly positioned between two other major characters of this century: Marilyn Monroe and Adolf Hitler. The absolute Man and Woman, St Sebastian offers his body which is conditional and sexless, although substance was always provisional.

The rules of the game have become more stringent – St Sebastian is still the victim but this time God is not satisfied. We still need a scapegoat. However, culture turns into St Sebastian itself. It becomes the third sign. It cannot appeal to the masses any more. There is hope of seeing the third millennium. It removes the taboo and sadomasochistically consumes its own death in order to selectively reincarnate, not to be born ever again.

NOTES
1 Interview, 1991, with E Susloff, art critic, in New York.

GAMES IN THE TWILIGHT
VALERY CHERKASHIN'S MUSEUM METROPOLITAN

P resent generations look on the Moscow metro as a means of conveyance, another public transportation facility, nothing more. In the 1940s, however, before the Great Patriotic War, when the first lines with their underground palaces of marble and crystal were opened, the metro was received by its passengers as a miracle of Stalin's epoch, one of the great victories of Socialism. Cherkashin's art has created a semantic field in which the capital's underground regains the status of, if not a political then at least a social symbol of the epoch.

Valery Cherkashin came from Kharkov, studied with the 'Underground' in Leningrad, absorbed the traditions of the avant-garde and painted in high-quality water-colours. His dangerous passion for refashioning visual and empirical givens into the unbelievable came into full force when his experiments with photography reached their maturity at about the same time as *perestroika* erupted.

Cherkashin was appointed director of the Museum Metropolitan, founded in the early 1990s. This is not the museum in Central Park in New York, but the conceptual museum of Moscow's underground, with its statues and reliefs, people and perspectives, red partisans and drug addicts, dirty marble and the most educated passengers in the world; with its obscenities, the nouveau riche (their Mercedes undergoing repair), pickpockets, secret doors and market stalls with metres of pornography for sale, border guards and ballerinas. The metro is a sanctuary of Lenin, McDonalds, Jesus, the Devil and the central market, to say nothing of the KGB.

Twilight is descending: the twilight of gods, people, ideas – the beginning of chaos, confusion or (scientifically) entropy, the cleansing of identity. Valery Cherkashin works a great deal with these problems, the same subjects that Gogol, Paul Klee, Daniel Harms and perhaps Gary Hart dealt with. Cherkashin's collages, in which prodigious installations and memorials – the Moscow metro, the VDNKh Exhibition Park – are combined with signs, symbols and the tired, irritable inhabitants of the epoch of Socialist capitalism, to produce a jumble of visual impressions. A triumphal arch, a string bag, gold, an unwashed neck . . . In the era of the victory of democracy, Cherkashin's games in the twilight are a therapeutic cleansing for souls clogged with fear.

What Cherkashin does with photographs by altering the surface or the colours undoubtedly has a genetic connection with the pure, visual, plastic experience of the Russian avant-garde of the 1920s. That tradition was abolished/annihilated by the very layer of culture which Cherkashin now chooses as the partner in his artistic dialogue – the culture of the 1930s to the 1950s, the totalitarian culture. Cherkashin equalises the two traditions in his imaginary *Museum Metropolitan*, inducing a mixture of the incompatible and allowing the visualisation of one through the other. He paradoxically removes the contradiction by seeing that both traditions are part of history and can in the future become part of the same culture.

Cherkashin's abilities incline towards universality. This is evident in his wish to work simultaneously with photographs and type, colour and space, plane and volume. It is evident in his removal of the border between life and art, in his wish to make this border relative. It is evident in his wish to fulfil the people's collective dreams, only he wishes to do it using art, in contrast to the methods used by the Communist regime.

For Cherkashin, Post-Modernism carries an intonation of the *post-factum*, a glance after the end of the epoch, the feeling that everything is over and yet not completely over. The anxious, uneasy assimilation of this intonation into present reality needs to be accomplished through the strength of art, and this situation, resulting from the moment between one historical time and another, can be turned into something aesthetic, fascinating and paradoxical. It is an indication of battle with something that, from time to time, still bares its fangs: what remains of a layer of life of the recent epoch. That epoch needs to recede into its own past and come to completion, so that it may die and after death be resurrected through art in the Museum Metropolitan.

Taken from critiques of Valery Cherkashin's work by Professor Anri Vartanov, Alexander Yakimovich and Sergey Kuskov.

Valery Cherkashin, *The Hall of Valery Cherkashin's Museum Metropolitan*, 1991, photo-collage, 80x100cm

Valery Cherkashin, *Underground Butterfly*, 1992,
photo-collage, 110x130cm

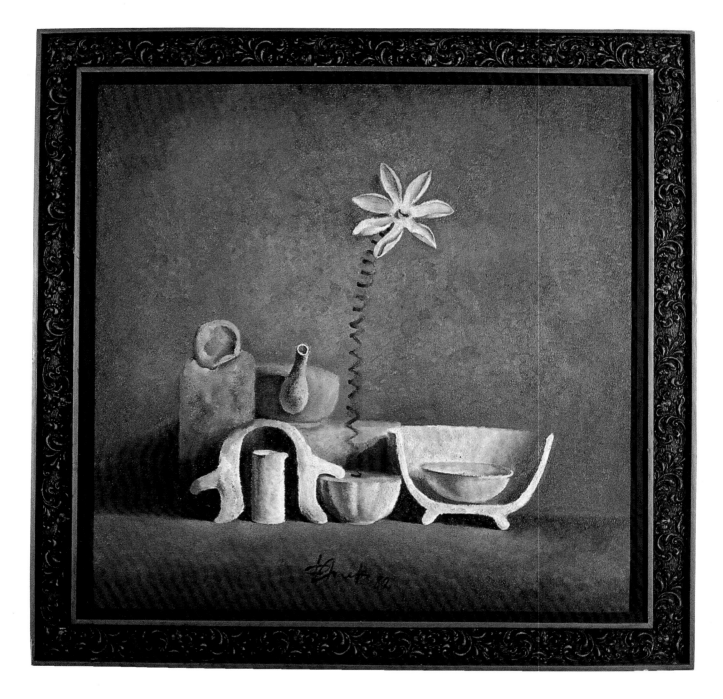

LANA SHIKHZAMANOVA

THE EASTWARD VOYAGE OF POST-MODERNISM
The Home Theatre of Faik Agaev

Over the last few years the situation in Soviet/post-Soviet artistic life has changed dramatically. The concept of 'alien', once so shocking to hordes of art historians and artists, has become domesticated and acceptable on the pages of newspapers and journals and on the television screen. Nonetheless, even after the existence of Post-Modernism in our country has been acknowledged by art critics, they continue to question its 'authenticity' on Russian soil, to count its locally missing characteristics and to determine what features are uniquely native. However, the very absence of complete coherence is absolutely natural and dictated first of all by the difference of environments forming this phenomenon in Russia and in the West.

American, or European Post-Modernism, is a trend which emerges and exists in a world of order. The post-modern destruction, cold manipulation of the shards of traditions, ironic play with the shells of concepts and images and attempts to combine them in some new object, take place against the background of relatively calm and measured existence.

In our mother-country, the situation is diametrically opposed, as in a mirror. The backdrop and the performance have changed places. Unlike his Western colleague, who is eager to shock bourgeois society in pursuit of his artistic mission, the Russian artist is formed by a society which has long borne the idea of destruction and has fallen victim to it. This society is unlikely to be shocked by the actions of destruction or by any ironic paradoxes: the absurdity is inevitably perceived by the post-Soviet man's subconscious as a norm. Therefore, the relation between art and life is also inverted, which leads to the substitution of the former with the latter (paradoxically, but then all the elements of post-modern art – irony, theatricality, destruction, combination of the incompatible, confusion of genres and styles – turn out to be more applicable to Russian life than to Russian art). Such a substitution organically results in the fact that the contemporary artist would rather gravitate to the creative and not to the destructive aspect of Post-Modernism.

Equally specific is the state of affairs in Azerbaijan. The processes typical of the Soviet Union in general did not spare this republic, a part of the late empire. An important factor, in addition, is that the majority of Azerbaijani artists were educated outside their native country, at the art academies of Moscow or the Baltic States, and therefore were professionally oriented to the achievements of Western artistic systems.

Azerbaijan has always been at the crossroads of trends from the traditional East and the modern West, of ancient ideas and the newest concepts. Azerbaijani culture was historically open to a variety of heterogeneous influences, ready to absorb and synthesise them; it is not surprising that the perception of the latest phenomena of Western artistic practice was more organic here than, for example, in the Central Asian republics. And yet it is necessary to point out that during the last two decades 'Western' influence worked in parallel with that of the medieval Muslim artistic culture perceived in Azerbaijan as national tradition.

Faik Agaev, *Still Life*, 1982, oil on canvas

Both genres have some interesting points of contact in contemporary Azerbaijani art, especially manifested in paintings. One of the examples is the work of Faik Agaev, an artist from Baku. The life and the paintings of Agaev represent a strictly defined sequence of enterprises. Each enterprise, as well as each picture in his studio, has its pigeon-hole; that is the date, method and place of execution. Agaev is a creator of order. The order established and cultivated by him systematises and ritualises the whole process of his creative activity, dividing it into several stages unchangeable in their sequence. The first stage is the search for and collection of objects for the future still life. Agaev can spend weeks and months in quest of something he considers necessary to his purpose. Patience and methodical exploration – in the course of which he visits the most unexpected places in the city – strangely contradict the complete absence of any idea of what he is looking for and therefore the absolute unpredictability and accidental nature of the find. The artist finds and picks up deformed and broken pottery, fragments of spoiled objects, pieces of wire, used boxes. The objects forming his still lifes are nearly always defective.

The second stage of his work is the destruction and deformation of objects. Not content with the material he has collected, Agaev saws apart ceramic objects, a process which can sometimes last weeks.

The destruction of the object so methodically performed by the artist is not necessarily connected with its concrete physical deformation. The same destructive property is also inherent in its up-rooting from its original context and its subsequent transference to some new environment, which means the destruction not of the object but of its utilitarian function and the emergence of a new function.

The theme of Death looms large at all stages of Agaev's work in any picture, and is essential (though not always manifest) in his approach to art. The very choice of objects speaks for itself, especially in the case of his still lifes. The majority of them are ceramic artefacts, the basis of which are clay, earth or the world itself. Earthenware made of the 'dust of the earth' from time immemorial has served as a reminder of mortality, for the material of each of the new works is 'dust' which was once human flesh. This follows the tradition of comparing clay vessels with the human beings resurrected in them; in antiquity such vessels were often used as the last shelter of a man.

The artist also uses special medical tableware, designed for bedridden patients. Though the contemporary spectator could not define the function of these strange objects, the intensification of the Thanatotic theme in the decoding of the subject is beyond doubt.

The reason for the destructive actions of the artist is not merely the lack of acceptance of the whole (although this also is true), but some specifically realised wish to equalise all the components, which means first of all the destruction of the hierarchy in all its manifestation. Collecting useless splinters discarded by life, the artist to a certain extent saves them from oblivion and gives them new life. But as far as the coexistence between the fragment and the whole in the framework of the future picture would be unjust, he prefers to destroy the whole by making it equal to the part.

The only objects to remain intact are those of mass industrial production, and this is strange. Such ready-made artefacts are collected by the dozen; the artist amasses scores of similar cups or dishes as if

emphasising their absolute equality. Thus emerges a paradoxical combination of destruction and creation, death and resurrection; thus destruction simply becomes the beginning of creation, a step in its direction.

Like many other artists of today, Agaev 'tries' himself in different roles at every stage of his work. He begins as a collector interested in worthless material needed by nobody; later he becomes a destroyer (and creator); at the third stage he acts as an owner and stage-manager of a small experimental theatre and invents complicated *mise-en-scene* requiring decoding, and manipulates peculiar object-personages. The smooth surface of a table where each of his still lifes is assembled is a kind of stage for a specific play-performance enacted for the missing spectator who would understand everything despite the multitude of senses and codes inherent in the play.

At the same time the performance evokes some completely different associations. The bare table with a still life illuminated by strong artificial light, the deformity and distortion of the elements composing the still life, and the artist himself, always clad in a pristine medical coat, unmistakably reproduce the atmosphere of an operating theatre. These hospital associations are emphasised by the sterile and ominous order in the studio which the layman would never recognise as an artist's sanctuary. The studio of this artist could be taken for a laboratory at some medical institute, for the workshop of an artisan or an alchemist's study. The shelves lining the walls are carefully stacked with chemical reports, medical glassware, complex technical instruments and boxes with bright labels. The studio seems to absorb the functions of the objects and forms some incomprehensible, semi-functional system.

The common denominator of this medico-theatrical performance, of this play-operation lasting for days as the object undergoes numerous changes, is the cold and detached position of Faik the Producer and Faik the Surgeon, as well as his detachment from the obscure scenery. The vague uncertainty (or maybe absence) of the real sense of the work is typical of Agaev's whole artistic method. Even when the long process of assembling is over, it culminates in just an 'intermediate finale', as in a film or a theatrical performance, with the final scene yet to be played.

The performance is over, and here comes the last stage of Agaev's work. In the artist's study there remains a handful of strange objects arranged on the table, and the only thing for the artist to do now is to represent them on canvas, after which he will call the finished picture (as he has done for years) 'still life'. What happens in reality apparently, and only apparently, follows this pattern. The artist meticulously transfers the composition to the canvas, almost as if he were photographing the created object. However, even a photograph, considered the most objective representation of reality, is nearly always biased as regards focusing, distance or exposure.

As far as Faik Agaev is concerned, his copying is deceptive. The inscription on the door of his studio reads 'Magical Realism'. This is somewhat conventional as are the majority of such self-definitions, but it has its background in some quite transparent quotations. The first point of departure is the widely recognised Magical Realism of contemporary Latin American literature, with its favourite mixture of fantasy and reality; but while the realities of daily life are linked with fantastic situations there, Agaev uses the reverse method: he distorts reality by phantasmagorising it, achieving an upgrading of the trivial object's status.

The second demonstrative quotation is the still lifes of Giorgio Morandi. The accentuated classicism, laconic brevity of form and colour, the calligraphic signature of the artist representing his name in full, written as if by the hand of the famous Italian, are all the figurative message to the master of metaphoric still-life from the Apennines.

This gesture corresponds with the medieval Muslim tradition of 'nazire', the answer to a predecessor, a great poet or artist, which presupposed the direct quoting of the main idea and structure but resulted in the creation of an original work in keeping with the times. Thus, the ironic 'nazire' of Agaev has at least two different sources: the traditional Oriental and the contemporary Western.

One might also recollect the German 'New Materiality' of the 1920s with its second name coinciding with Agaev's self-definition (Magical Realism) and some tendencies in the artistic practice of the 1980s (for example, in the works of the 'New Wild' in Germany), with its penchant for ancient magic. This interest leads the artist on the one hand to the borrowing of certain elements of ancient cultures, while on the other to the attempts at converting a contemporary piece of art into a magic object, at endowing it with some magic qualities.

In many respects, Agaev is adept at this trend, but it again brings him into contact with the tendency to assimilate the Oriental tradition which is typical of contemporary Azerbaijani art, where Orientalism becomes the source of ritualisation and deliberate crypto-magical coding of the picture, the source of a special language understood only by the initiated elite. At this final and concluding stage of the picture's creation, the motifs discovered in the process of staging and assembling are often amplified and ironically played up. Slightly transfiguring, smoothing or accentuating some of the details, the artist produces still lifes that can be attributed to different genres (portrait, landscape etc) and different series combined by several common motifs often overlapping each other.

One such series demonstrates mechanic motion: the strange creatures of these pictures seem to be slowly moving, and resemble the amusing mechanisms of Tinguely. Death, corroborated at first by the title *Memento mori*. The pictures feature semi-opened boxes containing object-personages, though the sombre rituality of the coffin-box can also be translated as a solemn demonstration of the precious object kept in the box. Such a translation perfectly corresponds with the traditional Oriental idea of the hidden treasure.

Thus, in his work, Faik Agaev passes through the four major stages conventionally characterised as:

1 Search and collection
2 Destruction
3 Play and assembling
4 Fixation, or creation of an artistic copy of the assembled object.

Clearly, in the course of his work there occurs a shift of accent from the final result (ie the picture) to the lengthy process of artistic action emphatically focused upon the 'intermediate finale', that is on the assembling of the still life. During this long period, the artist manages to cover the whole process of art in the twentieth century – from Modernism to Post-Modernism. As a result we witness the existence of numerous heterogeneous elements representing quotations from various artistic tendencies which have coexisted or replaced each other during the twentieth century.

Faik the Collector, and Faik the Destroyer playing with death, are simultaneously and paradoxically Faik the Creator, for the play of destruction becomes a necessary (if only a composite) element of the play of resurrection, and as such, a real step towards creation.

There are at least two other sources for his ideas. The first, as mentioned before, is traditional Muslim culture. Its influence is less evident, less clearly expressed in the plastic and visual order of his painting than the indisputable influence of American or European art of the twentieth century, but it can be explained by the fact that the artist depends on the philosophical heritage of the medieval Muslim Orient to a much larger degree than on its artistic patrimony. Another point of departure is undoubtedly classical European art with its devotion to realistic form, voluminous and spatial characteristics of representation and specific chiaroscuro. The Post-Modernism of Agaev is an all-consuming system which includes, but does not dissolve, the codes of heterogeneous tradition.

Contemporary art destroys both spatial and temporal boundaries in literally trying to grasp the ungraspable, to include in its game the possible and the impossible, the near and the remote, the known and the unknown. But this all-consuming 'Post-Modernism' is still compre-hended mainly within the categories set by the West. Faik Agaev is a Western and an Oriental artist. His work proves that features of Post-Modernism can be distinguished even in a region such as Azerbaijan, that one more frontier is breached, and that more players are entering the game.

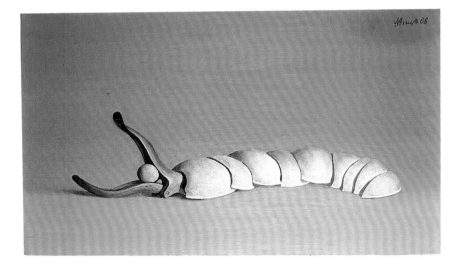

Faik Agaev, *Still Life*, 1988, oil on canvas

OLGA ZIANGIROVA AND MARIA TCHUIKOVA
THE EXPERIMENTAL LABORATORY

We are interested in the crossover zones of art and science, of humanitarian, natural and exact knowledge. Working at the edge of scientific research and artistic practice, we look upon our creative activity as an experimental laboratory that helps us to formulate our discourse and cultural constructions.

Contemporary art processes are, in many cases, a manifestation of Post-Modernist discourse, which has declared art itself part of the market. Thus they tend increasingly towards the spectacular, or even carnival, while other functions are driven into the background. Such a tendency in recent art has forced us to undertake research in another sphere of more serious, concrete and fundamental character, that is the natural and humanitarian sciences.

The conjunction of various trends, or formation of new disciplines which use a wider integral vision, such as synergetic or applied linguistics, seemed to us to be currently the most important processes in current intellectual debate. It is obvious that the social and natural world-vision has to change dramatically, and that the synergy of sciences, both natural and humanitarian, must prevail.

As it is, every discipline is a closed world with its own terminology, lacking self-reflection from a broader cultural position. However, after performing a series of artistic and expositional experiments, we discovered a method which combines the language of various sciences, and which sometimes reveals completely unexpected conceptual ideas.

This method involves the interposition of two existing means of description, ie rationally logical and artistically imaginative, and it has great potential. On the one hand, it could serve as a catalyst for integrative processes in science; on the other, it could uncover creative tendencies in contemporary art.

In our artistic activity we have used the languages of certain branches of science, such as mathematics, theoretical physics, computer science, structural linguistics, palaeontology, archaeology and geology. Here are some examples:

1 In an installation (book-object) called *The Letter of Happiness*, the subject of which was an infamous chain-letter, the principles of geometric progression were used to introduce new geometric parameters into the text. The size of the chain-letter was increased and decreased exponentially, making it disappear from the sight of readers into infinity. (Olga Ziangirova, 'Shizo-China' exhibition at the Avant-Garde Club, 1991.)

2 The basis of the 'Magnetic Monopole' installation was the well-known Utopian physical concept of the possibility of the independent existence of two magnetic poles. This idea, materialised in the form of two cylindrical 'poles' hung at a distance from each other, unexpectedly created an emotional and even dramatic effect, a manifestation of the ascetic, scientific concept of the extremes of separation. (Olga Ziangirova, Belyaevo Gallery, 1992.)

Golden discs used in *The Letter of Happiness* installation. The discs represent divine light and the power of the heavens, they were combined with the text of the chain-letter to obliterate its negative aspects, 1991, mixed media, photo Alexander Sidoroff

We are currently working on an international project called *Geological Mythology*, which will include a series of exhibitions in various countries. Parallels of vision and meaning between the 'mental' and geological landscapes of specific countries have to be drawn in the installations. (Distinctive mental characteristics of a population should be compared, and overlaid with, the country's physical and geographical conditions, with the help of the language of contemporary art.)

Scientists, artists and critics are interested in the possibilities of looking into each other's zones, hitherto inaccessible to them. As confirmation of this, the Russian Humanitarian University has asked us to organise an experimental culturological laboratory. As well as exhibitions, we will organise international seminars and conferences. It is to be hoped that at the overlapping edges of art, science and philosophy, new and unexpected ways of viewing well-known themes will arise, solutions will be found and new light will be shed on old problems.

Installation as the Model of a City

The Post-Modernist ideology of mixing media and putting together disparate objects led to the setting up of an experimental art project based on the theory of 'localism' (*lokus* = place). It includes a series of installations and performances in different Russian cities, in some way reflecting the specialities of the surrounding space and in particular the socio-geographic zones. Becoming models of the city environment, eliminating different angles and aspects of it, these installations lie on the border between visual art constructions and analytical reports expressed in an original system of codes.

Contemporary art discourses provide the possibility in a rather paradoxical way of putting together the realities of today's town and the memories of past historical periods, ideological concepts and cultural constructions. Such visual construction, which resembles laboratory work with models, makes it possible both for the authors and the spectators to discover hidden levels and unknown laws in the development of cultural and socio-political space.

It is likely that such an approach to exhibitional art was stimulated by the dynamic state of current Russian cultural space, its intensive changes and unprovisional future. This situation naturally creates the desire to fix the moment, to construct something that embodies it, to express various attitudes and positive intentions.

These installations are made up of a collection of smaller ones – photographs of installation views and artefacts, fixed in the city space. Each piece itself represents a particular level or an element of the city environment in its cultural, historical or mental aspects, expressed in a personal system of signs and visual combinations.

Preparations turn into a kind of mental cartography, pinpointing not only the stages of forming the planning structure of the town but the mutations of citizens' mentalities. Finally, such a model starts to communicate with the city itself through a series of performances and television programmes which are included in the show, opening art to wider interdisciplinary, ethnic, gender and political discourses.

This inter-regional art project started from two geographically opposed points: the southern and northern sea-ports of Odessa and St Petersburg. It aimed in part to discover and research the stages and directions of the development of imperial state power on the territory of Russia.

AQUA-VITA: A Project

The Southern and Northern Gates of 'The Way of Growth'
by Sergey Anufrieff, Olga Ziangirova and Maria Tchuikova

This project is based on the understanding of a place not as an abstract quantity, empty space or point on a surface, but as a concentration of different qualities and aspects. In the theory of localism, each territory, geographo-textual and provisional, is defined as a conscious object, having the spectre of different parameters, consisting of numerous levels and aspects, shining with all surfaces of its manifestation.

If any place, human-being or historical event can be the object-subject of research, so why then have we chosen cities? Being among all places constructed for the purpose of living, a city differs from all of them because it is a kind of art creation in which 'creator' and 'creation' are united. It is formed, giving shape to those who have built it, showing the qualities of both in a concentrated way, turning it into a focus of civilisation.

Each city has its individual system of codes, predicts and signs which are hidden in the landscapes of the place and planning maps. Compare for example the seven hills of Rome, the 'ship' of Paris, the 'golden horn' of Istanbul, the 'fish' of Bombay and cabalistic signs in Prague. These become the cities' symbols, charades.

Ports can be placed within a special group. While having communicative meaning they are usually compared to the doors or windows of the state. This may explain why they have more functional motivations in city-planning construction. The (former) Russian southern and northern gateways – Odessa and St Petersburg – have a rational rectangular planning structure, without sacral motivations.

St Petersburg etymologically represents the starting and finishing point of imperial power: 'the stone of the empire', 'imperial stone' (from *petros* – stone and *burg* – a combination of the meanings 'hill' and 'to keep') lead to 'the king on the hill', like the children's game 'King of the Castle'. This part of Eastern Europe, which was occupied by ancient Russia, was located on the historical scene as a 'way' from barbarity to civilisation, between two seas: the Black Sea and the Baltic Sea. It is closely linked to the idea of growth (*rost* means growth in Russian – hence Rossia). The south embraced the traditional state regime, the law: perhaps for that reason the 'third Rome' (Moscow) appeared and started to expand, creating the most huge and powerful empire in the world. The impulse for this was created by the Russian statement on the Black and Baltic Seas: the foundation of the two biggest ports at the beginning and the end of the 'way of growth'.

If, at the beginning of the way, the end is declared, in the end there is the concept of infinity, the endless way without beginning. Odessa's name comes from *odos* – a way, stream. The Greek colony Odessos was named 'on the way'. The shoreline of this city looks like an unfinished circle, a curve turning from infinity to outcome, a sign of change. It is combined with the nineteenth-century plan which resembles both an open book and open gates, a bird flying in the direction of the sea. Odessa is a place of outcome, a womb giving birth to children.

The scenery of odyssey influences the life of the city, and the life of its citizens, from sailors to geniuses. 'The way to power' turns into the way which loses itself endlessly; the way to the perfection of the changing ideal of culture and civilisation. Everything that follows such a way

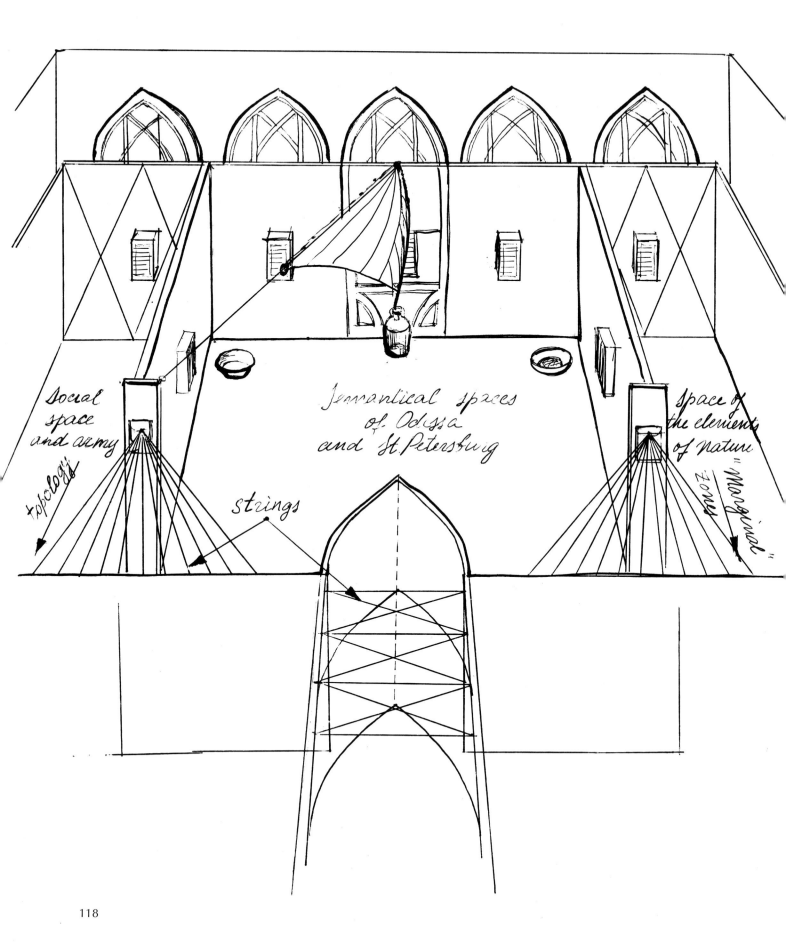

Social
space
and army

topology

semantical spaces
of Odessa
and St. Petersburg

Space of
the elements
of nature

"Marginal"
Zones

strings

without looking around at a superficial level can be lost in its perspective and become degraded. Such a result lay in wait for Odessa and St Petersburg. Parallel routes, formed by thoughts of growth, took the cities too far. Even in the last century they had strayed from the real ways of history. Logical, rectangular plans of these cities, worked out during the Enlightenment, created very naive mechanisms which could not survive the twists and turns of the history and culture of this region. Its levels and elements fell into disorder; they did not follow their dynamics.

Open, decentralised systems no longer existed. As a result, the old capitals – Moscow (Russia) and Kiev (Ukraine) – have once again occupied leading positions. Thanks to the structure of the totalitarian state (the USSR), the seaports – the gates – were closed, and the idea of renovation turned into just the opposite.

The show occupied the space of the new Centre of Modern Art in Odessa, and was divided into several 'zones'. The largest zone was devoted to the semantic structures of Odessa and St Petersburg, illustrated by artefacts; it was bordered by the social zone (including the themes of army and public relations) and the zone of natural elements, reflecting an actual ecological theme for both cities.

The marginal zone depicted the elimination of the underground, criminal life of the port-city – so active in Odessa, which is sometimes called the motherland or capital of the criminal world. Among the objects in this zone was a dictionary of criminal slang 'trapped' under some baskets.

An important element of this installation was the system of strings, arranged to create spaces. They appeared in the minds of the authors to be the image of impulse and constructive support which is so lacking in the sleepy atmosphere of Odessa today. Taking into consideration the fact that social and political change begins with essential changes in the collective (un)consciousness, activated by creative thought-forms of cultural innovations, the authors discovered the image of 'Aqua-Vita', mythological water which gives new life to the dead.

Placing in a particular order the codes of the two cities, activating them in a positive, dynamic way and provoking the generative, productive aspects of their symbolic facets, the authors hoped to fill the dried-up stream of the ancient way from barbarity to civilisation.

The first show of this cycle opened in Odessa in October 1993 and included photographs, objects, paintings and constructions. Authors: Olga Ziangirova, Maria Tchuikova, Sergey Anufrieff. Curator: Margarita Jarkova. Sponsors: TIRS, TOH. Other participants: Alexander Sidoroff, Yury Dikov, Vadim Bondarenko, Igor Gusev, Anatoly Shevtchuk.

Plan of Aqua-Vita project, October 1993, Odessa, black-and-white sketch

EVGENY SOLODKII
DETERMINING THE POINT
Yellow Mountain Group, Bureau of Scientific Research

Man shall not live by bread alone: that is why he invented art, Post-Modernism, the glorious city of Saratov on the Volga and the Bureau of Scientific Research situated within its limits. I am Evgeny Solodkii, an architect-turned-artist, and I am part of the equation, for the idea of the Bureau is at least partly mine. The Bureau is engaged in a number of purely scientific projects, and those taking part in them are required to be nonchalant and poker-faced under any circumstances. The very fact that it exists proves that the new trends in art did not by-pass the Russian hinterland. This area gave birth to a group of young artists who discarded everything they learnt at their institutes and chose their own way. The group is known as the 'Yellow Mountain', and the author is one of its founding fathers, although he prefers to label his production with the hallmark of the aforementioned Bureau of Scientific Research. A way within a way, so to speak. The following are some milestones:

– *Performance of the Determination of the Point*, Griebannaya Proletarka, southern slope, 27 March 1993

– *Griebannaya Proletarka*, western slope, 7 April 1993

The aim: Simulation of the sunlight reflected in mirrors to determine a pleasant place.

Equipment: Four mirrors.

Procedure: The four participants moved at will holding the mirrors. They

stopped when a circuit of consecutive reflections was formed. When the last participant closed the chain, the sunlight moved in a circular movement between the mirrors, becoming independent of the sun. That position was maintained until darkness, in order to test the sunlight circulation and to fix a pleasing place at the centre where the rays bisected one another.

– *Performance of the Daytime Stars' Projection*, Mikhailovka village environs, Saratov region, 8 August 1993

The aim: Determination of the daytime stars' projection on a 72,000 square metre lot for the subsequent calculation of the distance between the stars.

Equipment: 'Daytime stars' projection apparatus', consisting of a model of a deep well (a 1.20 metre pipe attached to a light-proof bag) which provides the possibility of seeing the stars in the daytime. Owing to the special hinge system, it can be kept strictly vertical. The bag is placed over the head.

Procedure: The three participants with the star-projection apparatus moved at will across the lot until they established visual contact with a star. The participants stopped, and the point of the star's projection was fixed. Since construction of the apparatus permitted only the sky and the stars to be seen, the movement of the participants was corrected by a guide with a megaphone in order to prevent an undesirable fall or collision.

So far so good, isn't it?

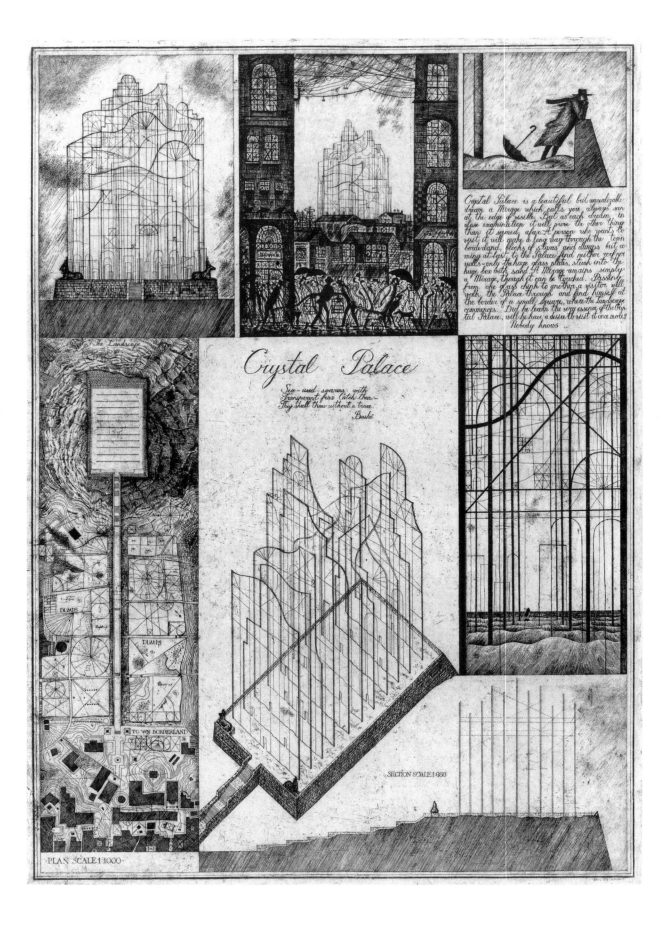

Crystal Palace is a beautiful but unrealizable
dream, a Mirage which calls you always seen
at the edge of visible. But as each dream, in
close examination it will prove the other thing
than it seemed afar. A person who wants to
visit it will make a long way through the town
borderland, blocks of slums and dumps but co-
ming at last to the Palace find neither roof nor
walls - only the huge glass plates, stuck into the
huge box with sand. A Mirage remains simply
a Mirage, though it can be touched. Passing
from one glass chip to another, a visitor will
walk the Palace through and find himself at
the border of a small square, where the landscape
commences... Did he learn the very essence of the Crys-
tal Palace, will he have a desire to visit it once more?
Nobody knows...

The Landscape

DUMPS

DUMPS

TOWN BORDERLAND

PLAN SCALE 1:1000

Crystal Palace

Sea-weed swarms with
transparent fries. Catch them.
They shall thaw without a trace.
Bashō

SECTION SCALE 1:666

ALEXEY TARKHANOV
POST-MODERNISM ON A SCALE OF 1:666
The Phenomenon of 'Paper Architecture' in the USSR

The belated second advent of Modernism blossomed and thrived in the USSR during the 1960s. The famous Communist Party resolution of 1957, 'On the liquidation of excesses in design and construction', inspired by Khrushchev, outlawed nearly everything which had motivated architecture in the preceding twenty years: historicism, orientation to Classicism, richness of material and abundance of detail. The end of the 'Stalinist style' had a lasting effect on architects, dissuading them from the use of columns and porticoes.

Nevertheless, by the 1980s the struggle against the excesses had become increasingly formal as it passed from the pages of Party documents to the realm of professional expertise, construction norms and regulations. On the one hand it normalised functional demands by raising them almost into the rank of the law, while on the other, it created an opportunity for professional agreements, mutual 'frame-ups' and mutual concessions.

The Party brass continued their interference in architectural affairs, but the all-enveloping economic and ideological pressure of the early 1960s was no more. And in their personal commissions, the bosses undoubtedly preferred 'pretty', 'rich' and 'traditional' architecture. Prestigious orders from the Central Committee and the personal tastes of Party secretaries undermined Modernism in architecture, while the latter and particularly residential construction came under fire from critics who blamed it of being 'faceless' and 'monotonous'. Yet the luxury of occasional disobedience to the rules was the prerogative of the older generation grandees exclusively.

In general, the struggle between Modernism and Post-Modernism on Russian soil was by far limited to a theoretical contest between the two aesthetic systems. It was perceived, firstly, as a conflict between society and architectural bureaucracy; secondly, as an inter-professional conflict, and thirdly as a conflict between the generations.

The Attempted Escape

It was against this background that 'paper architecture' emerged. It is known also as 'easel architecture', though the latter term has never become widespread. The term at first sounded familiar, for from 1917 to 1919 when any real construction simply did not exist, 'paper designing' was the name for authorial concepts which could be expressed only in the form of projects. From this the somewhat negative character of the term was inherited, which, however, has never disturbed the authors. The definition, though partly enforced, was accepted by them readily.

When they first came up against paper architecture, critics tried to compare it to the old competitions of the 1920s – for the Palace of Labour, the Theatre of Mass Action, the Red Stadium – and to therefore justify it by tradition. However, it became progressively clearer that the phenomenon in question was something different.

The architectural fantasies common in the 1920s were providential, positive and optimistic, mostly tending to exaggerate the real virtues and abilities of the craft. Paper architecture dealt with similar age-old fantasies,

Brodsky and Utkin, *Crystal Palace*, 1989-90, image etching, 83.3x59cm (Ronald Feldman Fine Arts, New York)

with one important difference. As a sign of the 1970s and 80s, traces of parody and even jokes at the expense of the holy of holies of the profession appeared.

In the 1980s, unofficial art stood openly against official art, and celebrated its victory as early as 1987 after the triumphal success at the Sotheby's auction in Moscow in July. Paper architecture turned out to be a part of this process. From the very beginning, it resembled not a quirky professional game but an attempt by young architects to achieve personal freedom. Surprisingly the attempt worked well, at least because the prizes awarded by foreign journals guaranteed a comfortable existence for the winners in Moscow in 1986. For the first time in the history of the USSR, there appeared architects independent not only of capital projects organisations but also of the Union of Architects or any official structures. It is more than evident that such a situation could only irritate the architectural functionaries.

The Oedipus Complex

In paper architecture, not only the motif of professional polemics but also the detached and somewhat hostile attitude to the profession itself were too explicit. The very idea of the project invariably parodied the habitual architectural lexicon. It could be a parody *par excellence* when a new residential complex was replaced – in the course of the search for some 'Style of the Year 2001' – with a seventeenth-century urban landscape. It could be a parody of representation felt in every line, in the mocking scale 1:666, in the serious enumeration of prototypes of the project: the house of Winnie the Pooh, the hut on hens' feet, the three-staged rocket . . . Soviet authors made no bones about mocking architecture in general and the theme of a given competition in particular.

The idea was not to widen the frame of the professional lexicon as many critics hoped for. The paper architecture projects were humiliatingly eloquent in demonstrating the impotence of real architecture. The self-assertion of the young might seem to be a dangerous revision of established values and myths.

Crystal Palace

In 1981, M Belov and M Kharitonov were awarded first prize by the journal *Japan Architect* for their project of an exhibition hall in the grounds of the Twentieth Century Museum. In this artistic work, almost all known means for the creation of emotional effects were used: Baroque perspectives, sharp changes of scale and rhythm, light contrasts. Wanderings through the exhibition hall remind one of a funfair, an expressionist film and simply a dream with a continuously repeating mask-motif. The visitor strolls along endless corridors feeling either like Gulliver or a Lilliputian. Irrationality reigns in this strange world. However, according to the conditions of the competition, the building not only had to accommodate the visitors but had to be used for living as well. Thus, in parallel series of drawings, the authors, generous as conjurors, reveal all its secrets and furthermore turn out to be ingenious in showing the everyday life where the calm rationality of the dwelling once more assumes its rights.

This project which displayed the two faces of architecture made a remarkable impression. But the real symbol of competition practice was undoubtedly *The Crystal Palace of the Twentieth Century* by Brodsky and Utkin. In the last century, it was precisely this luck in competitions that led

to Joseph Paxton becoming the architect of the gigantic palace of the First International Exhibition in London, and thus into a spokesman for the new spirit in architecture. Built in 1851, over just six months, the Crystal Palace disappeared in one night, destroyed by a fire in 1936. The noisy disputes in which praise and negation mixed, as well as the destruction of the beautiful building, made the Crystal Palace a kind of symbol, an architectural phoenix reborn in fire. It is often the Crystal Palace that opens the genealogy of the 'Modern Movement'.

In 1983, this image was interpreted quite differently. What is the Crystal Palace of the twentieth century? The wonderful fairy glass fantasy looming above the city turns into a mirage. This is the authors' explanation:

The Crystal Palace is a magnificent fata morgana looming at the horizon and always luring towards itself; but when inspected from a close distance turns out to be something quite different. It is situated outside the city. If you want to go there you have to walk a long way through the suburbs, through the heaps of rubbish and when finally you enter the Palace you will find neither roof nor walls – just huge glass surfaces stuck into a vast sand box. The mirage remains a mirage, although you can touch it. The visitor, passing from one glass aperture into another, will cross the whole palace and reach the edge of the site and see the landscape . . . Has he understood what The Crystal Palace is, will he come again? Nobody knows . . .

Literature

Each of the drawings has an elaborate and sound literary background. This culture of scenario is astounding in an architectural work. Any conversation about 'paper architecture' does not begin with enthusiastic quotes from the texts explaining the drawings for no particular reason. These narratives can be different – in scope, quality and sense. There are legends – mysterious, philosophical and even ominous; there are anecdotes such as the Museum of Equestrian Sculpture which is represented as a stable, or a 'theatre without a stage', and there are refined fairy tales about the rose in winter and the chunk of ice in summer – in the 'climatrone' conservatory surrounded by Versailles park.

The project always centres around a literary image, at least partly because the competition task is formulated in words. And even the fact that the formulation has come from some master of architecture who invented the theme of the current competition cannot alter its initial 'literary' character.

The literary formulation always rids authors of any graphic prompting. They face a real literary rebus: the 'Exhibition Hall', the 'Bastion of Resistance', the 'Crystal Palace', the 'Atrium', the 'Style for the Year 2001' – all themes appropriate for an article or essay. And it would be logical for the judges to get a typed one-page answer, for the volume of the 'literature section' does not as a rule exceed 100 words. But where a sonnet or a note would suffice, comes a drawing seemingly telling the same things. Certain tautology is evident. Thus, the author of a novel could expound the contents of a chapter in verse or drawings.

The tonality of a literary narrative – like the captions in a silent film – precedes our perception, prompts us as to the genre of the work, and carefully specifies our attitude to the drawings. Furthermore, the tonality remains in our memory, when the direct impression of the drawings is gradually replaced (or sustained) by the spirit of a literary novel. It is very convenient for a critic to get a brief literary portrait of the work in advance –

something of a press release or a note from the editors.

This would resemble the 'visualisation' of a text similar to an artistic summary of a play or the creation of a book illustration, but for the fact that the literary legend appears in parallel with the graphic one. The process of self-illustrating cannot be divided from the personal literary analysis of the drawing. Narrativity becomes an obligatory condition of every work of 'paper architecture'. And it is even possible to find that sometimes literary virtues are proportional to their graphic counterparts.

Graphics

Techniques vary widely. The 'easel projects' demonstrate the motifs of drawings and paintings of the 'World of Arts' materialised in the fairy tale manner of Nicholas Akimov and Georgii Golts. Equally influential are the illuminated water-colours of the nineteenth century. The heritage of the 1920s is also popular with its signs of Suprematism, Constructivist finesse and design graphics in the style of El Lissitsky's PROUNs or the architectural fantasies of Jakob Chernikov.

This constantly reminds the critics that from the point of view of technique and style, no homogeneous paper architecture exists at all. The difference between its projects are as pronounced as between 'easel architecture' and 'architecture of the young' in general. To be under the same covers of the same journals does not preclude the crucial differences in personal tastes and predilections, as well as in the measure of seriousness with which the architects perceive their field of activity and their contribution to it.

Architecture of Mass Media

The very first projects of Soviet 'paper architecture' changed the scene of competition practice, converting it into a peculiar dialogue where the answer to a specific task acquired wider meaning than had been foreseen in the formulation of the problem. The works brought to life by the concrete competition task were interesting, even outside the hierarchy of this or that contest. Subsequently, certain motifs and even complete drawings could be seen at artistic exhibitions in the graphics sections.

Nevertheless, it is a chance occurrence for a real architectural project to be demonstrated at an exhibition. On the other hand, easel projects are done for exhibitions only. Many of them can be perceived only in the original, which partly explains the easel-architects' penchant to graphics copied individually, such as etching and printing by silk-screen.

For all the use of graphics in contemporary design, the best impression is produced by easel architecture, for graphics alone can visually represent the object's essentially evasive image. This is reflected by the very name of 'paper architecture', a not too successful, accidental one. Paper architecture is intended for a page of paper, a journal, a book and because of this (for its specific nature) it was the winner over architecture in concrete or glass.

Paper architecture was created by journals, and its popularity depended to a high degree on the habit acquired in the 1980s – of measuring the popularity of an author by the number of works published and not the number of buildings. At first, the competitions were seen to be of secondary importance, either promoting or hampering the real practice. It could be claimed that initially the results were limited to a call to abandon those trifles and to start serious work. Such was the predominant opinion. Rarely were the young architects told that their works were the more interesting, the farther they were from real architecture.

Those who were engaged in the paper competitions of the late 1980s were very different people. Firstly, they included the temporary dissenters who abandoned 'major' architecture only for the time being through professional difficulties or for self-assertion, or in the painful period of apprenticeship. They were eager to take the first opportunity to start 'real' activity, and such an opportunity came in the early 1990s. The second group had fewer connections with the actual practice of architecture. Nevertheless, they considered their activity purely professional. Competition successes were seen in this case as a lucky chance to enter the profession through the front door. Finally, there existed a narrow circle of authors for whom the competition work became a special occupation with no direct relation to architecture. It was they who produced the most refined and interesting projects. Architecture gave them the means to deal fruitfully with book illustrations and easel graphics; they strongly resembled the artists in many respects. They even preferred membership of the slightly more liberal Union of Artists to that of their native Union, but differed from the artists by their ability to 'read' architecture and to express the most complex emotions in purely architectural images.

The artistic destiny of the easel-architects was dramatic. Their relations with architecture were complicated and contradictory from the very beginning: they claimed a complete split, but internally their coherence with the profession was unshakeable. The split was manifested in the demonstrative rejection of the values of the abandoned craft, in the unwillingness to adapt to its structure and in the parodying of its language. The coherence, as it is easy to understand, had the same roots. The use (even the most ironic) of architectural tradition in easel architecture was inevitable, and even a complete rupture with the trend would have become nothing but a professional gesture. The projects entered the sphere of interests of art galleries, but the unrealised attempt at leaving architecture was not a success. Nevertheless, in the early 1990s architecture as such also underwent a change, while large international exhibitions of 'paper' projects seemingly finalised this phenomenon: brought to life by unlimited Russian free time and Western architectural journals.

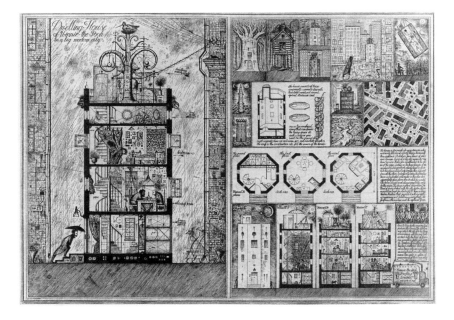

Brodsky and Utkin, *Dwelling House of Winnie the Pooh*, 1990, from Projects portfolio, 1981-90, etching, 59x81.5cm, photo D James Dee (Ronald Feldman Fine Arts, New York)

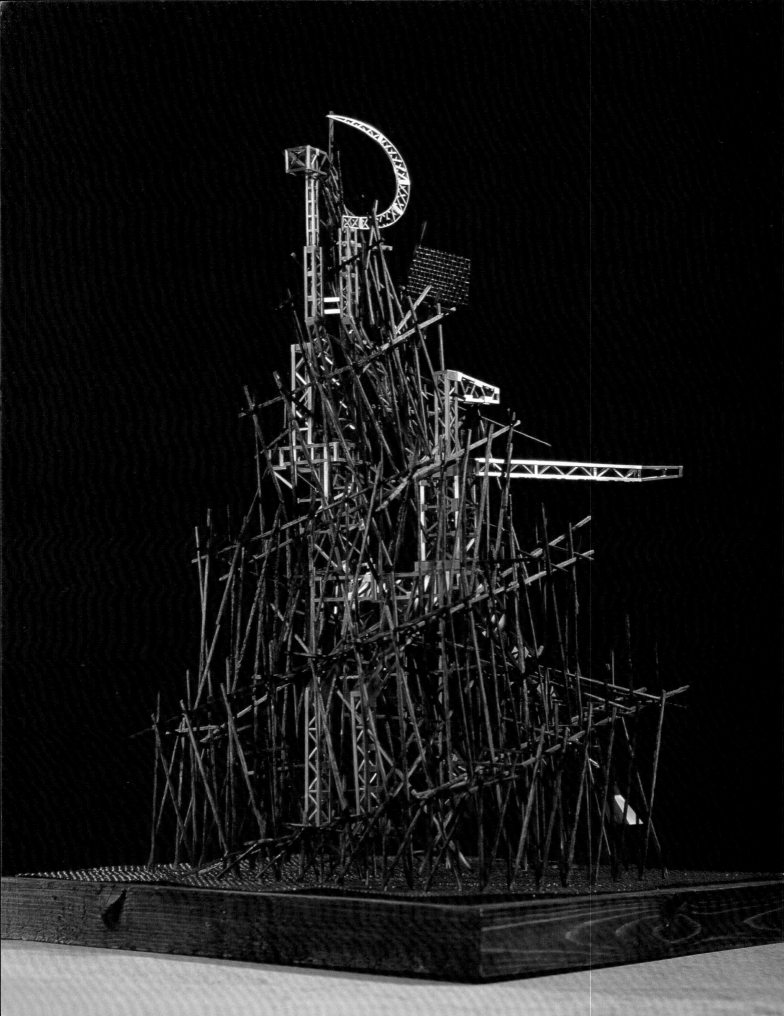

ALEXANDER RAPPAPORT
PAPER ARCHITECTURE
A Postscript

It's only a paper moon . . . '

'There was once a soldier – a paper soldier . . . '

The Quick and the Dead

The triumphs of young Soviet architects in the Japanese conceptual competitions of the 1980s came as a surprise to everyone – to the Japanese, the West, the Soviet architectural establishment and perhaps even to the victors themselves. For since the early thirties the architecture of the Soviet Union had been if not actually dead, then at least considered to be so. Its range of possibilities lay between the poles of cheerless monotony and false pomposity and any exceptions were eliminated through the system of state and party control. But then suddenly . . . this virtuoso draughtsmanship, this witty invention, compositional mastery, these rich cultural associations, this economy of means . . . the list went on. Even the branch of art in which it all happened came as a surprise; gifted youngsters were still to be expected in music, since the performance culture of the USSR had not been destroyed, and mathematics and gymnastics also turned up prodigies, but in architecture all hope seemed to have died.

The young architects who won the competitions on paper were astonished not only by their talents but also by their strange behaviour. Unlike their precursors in this field, they made no vows of fidelity to progress and did not promise mankind happiness. Contrary to the hopes of the famous poet Andrey Voznesensky, himself a former student of the Moscow Architectural Institute, who had extended a fatherly greeting to the new generation, they did not demand that their castles in the air be incarnated in glass and concrete. So they became known as the 'paper' architects, a nickname which they readily accepted. And paper architects they were – in the straightforward sense, although they were no paper tigers, and nor did they have paper souls.

Their competition successes allowed them a certain amount of property and frequent foreign travel – permitted, that is, the acquisition of the basic privileges of the Soviet elite, albeit on a smaller scale. Their prime advantage was their liveliness, the happy mood which surrounded them, shining out brightly against the drab and monotonous background of official culture. They held no common doctrines, seeming merely a group of diverse personalities, and the variety of their projects astonished no less than the excellence of their draughtsmanship. Due to the extremely complex language of their designs, what lay behind this variety was not clear, perhaps not even to the architects themselves or to their potential critics. Paper architecture resulted from the sudden destruction of two forms of censorship – the internal and the external. These people committed the most serious crime known to a totalitarian

Yavvakumov, J Kuzin, S Podyomshchikov,
Worker and Farmer, 1992

V Tyurin, *The Intelligent Market*, 1987, indian ink, aquarelle, 84x59.4cm, for Japan Architect competition

regime – they allowed themselves to do whatever they liked – and such a total and open disregard for censorship paralysed the censors themselves. Having broken down the dykes and dams of Soviet ideology, their architectural initiative seemed to gain so much momentum that resistance to it was useless, and thus the heroes of paper architecture avoided the fate of the dissidents.

Certainly, this paper architecture partly coincided with the aspirations of many Soviet architects, who suffered under the asceticism of official architectural ideology (whose banners bore the slogan 'Economy, economy and yet more economy') and who dreamt of the 'excesses' anathematised in the sixties. The young paper architects were exhibiting what amounted to a 'feast' – in this case not just the 'feast in the time of the plague', but also the feast after the long fast, the period following the lean rations of the socialist architectural 'Utopia'. So it was natural that carnival, nourished by the theories of Mikhail Bakhtin and the fantasies of Mikhail Bulgakov, became one of their most common motifs, as well as one of the interpretative categories used by their critics.

However, Soviet architectural thought had been ground down by ideology, and although eagerly awaited, this carnival was greeted only by a feeble polemic between those who supported architecture as a branch of engineering and those who claimed it as an art form. This polemic fed off the conflict between two ministries – the Ministry of Works and the Academy of Arts, which had gradually resumed positions on architecture abandoned under Khrushchev. In fact, paper architecture was such a rare bloom against the poor soil of these theoretical differences, that in comparison with it they lost all differentiation and sank indistinguishably into the same lifeless grey background.

However, in a Socialist culture a place has to be found for every phenomenon. A historical niche and historical parallels were sought for the paper architects, and much thought was expended on determining whether they might or might not represent a new stage of Soviet architecture. The unbuilt designs from the twenties by Ivan Leonidov and Yakov Chernikhov were evoked, Piranesi was mentioned, and finally still closer analogies were detected with the post-modern fantasies in the spirit of the *Roma interrotta* and the *Chicago Tribune* competitions. However, there then occurred the suspicion that paper architecture might be 'our, Soviet Post-Modernism', of which there was no need to be afraid, since one need never be afraid of anything that is new and progressive. It must be admitted, however, that Post-Modernism's 'progressiveness' later proved highly relative matter, and its kinship with paper architecture was gradually forgotten. Ultimately, paper architecture became a historical property in its own right but without the question of its place in history ever having been settled.

All this happened not so long ago, though it seems now to be the distant past. The events of 1991 turned the Soviet state into Atlantis. Almost fifteen years have already passed since the moment in the early 1980s when paper architecture first appeared, but in Soviet or Russian architecture no new stage of development has yet signalled itself. Overthrowing the socialist pipe-dreams and criticising bureaucratic stagnation became the stock-in-trade of every newspaper front page, and the departmental polemic over architecture lost any significance in the swirling chaos which was now politics: what only yesterday had seemed a sign of life against the background of death, something awakening in

the midst of deep architectural lethargy, seemed now to have been just a dream, lovely but ethereal. The old occult saying springs to mind: beware of what you dream just before you awake – it can be deeper than anything else you dream. However, dreams do not obey historical chronology; dream-time is made up of a series of successive episodes, of which the first and last, though perhaps separated in real time by a long interval, can coincide.

A History Outside Time

Post-Modernism reveals by its very name that it is a phenomenon rooted in history, directly opposed to the avant-garde of the beginning of the century. The avant-garde was the locomotive, rushing into the future and pulling the rest of the train behind it. Post-Modernism is the view from the rear carriage, following the avant-garde or, as the Soviet saying went, 'riding on the tailgate' of progress. However, the avant-garde did not move smoothly forward along the rails, it had to beat a difficult way for itself, and did Post-Modernism.

The Utopian ideas of the beginning of the century – whether Socialist or functionalist – were thrown out only with considerable effort. On the one hand, the pioneers of Post-Modernism exploited semiotics to unmask the pretensions of functionalism. On the other, the young generation openly declared its resistance to logic and positivism and its desire for 'contradiction and complexity'. 'Less is a bore', they said, not bothering to tax themselves to the extent of providing any proof. Western Post-Modernism, like the son of Noah, tried to gain authority by laying bare the illusions which were the architectural ideals of its fathers and grandfathers. The paper architects did not need to do that. In the USSR both the professional and the creative will of the architect had long been replaced by the will of the party, which in 1932 had distanced itself from all architectural Utopias except one – Socialist Classicism. In 1955 this Utopia, too, was discarded during the battle with 'excess' which established the most primitive construction style for the masses and a wretched aping of what was construed as the 'modern style' for the few. Qualified architects submitted, theorists adapted, but what was to be done with the students? Were more or less free drawing exercises all that was to be left to them? It was these drawings which found an unexpected market at the Japanese competitions for architectural ideas which established the genre of modern architectural conceptualism.

The history of the paper competitions, exhibitions and catalogues began in the 1980s. However, the public story of paper architecture's triumphs gives little idea of its historical purport. In order to understand that, it is worth taking a look at the place occupied by history itself in the paper designs.

The first thing that strikes one is that paper architecture can be seen neither as a form of revivalism nor as a form of futurism. The paper architects have never been concerned about the past or the future as such. They put super-technical constructions and classical forms to the service of an ironical game. The authors of these paper fantasies feel no veneration for past or future as they play with historical or futuristic forms. For them, as for Francis Fukyama, history is over. Does this mean that the 'eternal present', with its immortal constructions, has begun for them? Not a bit. Real time is nowhere at all to be detected in paper architecture; in its place is fantasy time, fairy-tale time. However, this

ABOVE: Y Avvakumov, J Kuzin, S Podyomshchikov, *Red Tower*, 1988, metal, 64x29x29cm; Vladimir Tyurin, OVERLEAF, LEFT: Cross building; OVERLEAF, RIGHT: Inspiration for *Worker and Farmer* – the structure inside Mukhina's famous sculpture, 'A Worker and Woman Member of a Collective Farm'

childlike shutting off of the imagination from real time leads them into schematisation.

These designers construct by combining raw architectural forms, by breaking architectural history down into shards, which they then use in a sort of kaleidoscope of the imagination, the turning of the kaleidoscope rendering up an infinite number of compositions. They may be ordered chronologically, but they do not constitute a history. There is a sharp distinction between this historical indeterminacy and that eternal style which is the traditional form of timelessness in architecture. Instead of timelessness in corporeal, substantial form, here we have a mindless infinity of possibilities, akin to Borges' Babylonian Library. The variety of the paper fantasies is generated by the mechanical combination of cultural clichés in the kaleidoscope of invention. With the plans of the paper architects, as with Post-Modernist structures, we see the birth of a new form of architectural hypnosis, hypnosis by possible, conceivable combinations . . .

If ancient architecture, like the ancient myths, was almost more real than real life, then the fantasies of the paper architects are less real than the elements combined to make them. They can seriously be viewed as a sort of professional and historico-cultural dream.

Recurring Dreams

What we have here are constructed, planned and exactly calculated dreams. For all they are fantastic, these games of the paper architects' imagination are still quite rational. It is precisely this rationality which makes them endless (it is the irrational which always imposes limits on man), and allows complete freedom of invention in both the choice of motifs and the way they are combined. Historical and theoretical devices are used as building blocks – metaphor, metonymy, hyperbole, association and paradox, oxymoron and inversion became an artificially generated grammar, whose possibilities turn paper architecture into the realm where anything is possible, in which the only source of limitation is the will, or if you like, the arbitrary decision of the creator. The strict rules governing the external presentation of each project – the obligatory page format, the predetermined number of drawings and blueprints and so on – hide the inbuilt inexhaustibility of its creative freedom. This inexhaustibility, however, is a dangerous thing, for it causes the designer's mind to become disorientated. Often the paper architects themselves play consciously on its ambiguities, repeating the alarming experiments of Mauritz Escher.

This is also the key to explaining the 'narrativism' which Konstantin Boym identified in paper architecture. Literary motifs serve as substitutes for real circumstances, becoming the pivots around which the fantastic designs are constructed, designs which can usually be reduced down to the level of illustrations of fantastic tales. There would seem to be an endless number of motifs, but in fact this is not the case. The motifs in the paper projects repeat themselves like recurring dreams.

These recurring ideas are the archetypal forms commanded by every professional designer: towers, bridges and so on. In the paper fantasies they are much more often to be found decorated in the sombre tones of anti-Utopian nightmares, than in the joyful colours of carnival. One finds no Piranesi prisons, but many of the designs are hardly much happier, as for example the dark etchings by Alexander Brodsky and Ilya

OPPOSITE: Vladimir Tyurin, *International Moscow University*, 1989; OVERLEAF, LEFT: Dmitry Velichkin, line drawing; OVERLEAF RIGHT, ABOVE: Vladimir Tyurin, *International Moscow University*, 1989; OVERLEAF RIGHT, BELOW: Dmitry Velichkin, Villa for 'N', 1992-93, in process of being built

контур проема

нашельник

8
резная деталь

Dmitry Velichkin, Villas, 1993

Utkin, or the monsters which people the glimmering spaces of their fantasies, inspiring thoughts of the terrifying chains which bind the languishing human spirit.

What, other than an all-too-evident horror of existence, could push the creators of many of these designs, happy and carefree young people on the surface, to produce jokes bordering on the cynical? In one of the projects we find a cradle-bridge. The bridge links the two sides of a river whose waters separate one people from another: the first person to step on to the bridge towards the others will fall through. It is not only in this design that feelings of hopelessness, of the vanity of all effort, show through – they are internal themes of many of these fantasies. Evidently, the paper architects' success could not stifle the ennui they had inherited from their historical predecessors. But almost for the first time in history we meet here not just ennui, but a diffidence concerning man's capacity to oppose and overcome the existentialist horror of living through professional works of art. For we find not only that nostalgia for the professionalism and culture of the past remarked on by Brian Hatton, we also feel a recognition of man's inability to return to that past. This recognition, however, appears cloaked in the form of a voluntary rejection of the professional ethos and deliberate mockery of professional naivety; it reveals a loss of professional pride. This debunking of the myth of professionalism, this unmasking of the professional Utopia may also signify a premonition of the death of the profession itself. Perhaps Victor Hugo was right when he foretold the death of architecture and the victory of the book over the stone in the novel *Notre-Dame de Paris*. Perhaps architecture really will perish, its living link with mythology lost, its flesh dissolved into rational reflections, its place surrendered to the designers' imagination, perhaps it is infecting impressionable young professionals with its death agonies.

The youthful blush and sparkling eyes of the paper architects begin to seem, far from signs of health, quite the opposite. In one etching for a design by Brodsky and Utkin – *The Ship of Fools* – a merry group of friends carouse on the roof of an unsteady skyscraper in a sea of smoking chimneys above a fantastical city. Their faces are recognisable as a circle of close, artistic friends – architects, architectural historians, artists - who have gathered perhaps for a birthday party. But is this a real birthday? Are not these friends in fact conducting in their own way a wake for architecture? And if we are looking at the burial of architecture, then the design itself must be, as the phrase goes, an attempt to make capital out of one's own funeral.

One of the symbols of death in art is the wind. Not the sort of wind which catches up the hem of those Communist leaders' greatcoats in their bronze statues but the sort which Nabokov uses to describe the death of Cincinnatus in *Invitation to a Beheading*. This is the wind that blows through many of the designs by Mikhail Belov. But other symbols in these architectural inventions also confirm the surmise of deathly forebodings in their creators. Brodsky and Utkin's design for that model of architectural beauty, the *Crystal Palace*, proves on closer inspection to be an illusion built on a municipal rubbish heap, and the flowers growing out of the urban litter turn out to be the blooms of dashed hopes.

The tower so often found in the paper architects' designs reminds one of Babel – both as a symbol of the vanity of man's daring and as the symbol of his fatal flaw. The other symbol which figures frequently in

these designs is the bridge. As the connecting mechanism between two worlds it is not itself a part of either of them – it is in between, halfway, in an existential void, seeming to share the indefinite historical fate of the paper designers. In the same way, Yuri Avvakumov's transparent staircases lead to nowhere – he turns the ancient symbol of ascent into a prerequisite for the setting of chaos, an echo of a skeletal ribcage, or a classical 'triumph of death'. Skeletal structures recur in many of the designs – the result of the rational dematerialisation of form. Windows, domes, doors, streets, towers, fences – the entire arsenal of architectural forms is before us in the form of denuded schemas: their flesh falls away and only their outline is left. Sometimes it is function which is schematised, as for example in the conceptions of museums, for which the paper architects produced many designs. The museum is another form of that bridge, it is a bridge across time, but in the design for a museum the theme of detached contemplation sounds even more forcefully. The paper architect strives to turn everything into a museum. In a design for an apartment block, Villa Mon Plaisir by Bush and Khomyakov its only function turns out to be the contemplation of a lone tree which stands beneath the windows in an enclosed courtyard.

Images like these give an insight into the fate of a profession – crowded out of life the architect becomes the sad contemplator of the historical collisions battering his own profession, of its fundamental superfluity in human affairs. This note is unsoftened by irony, for it is their form of irony – common 'black humour', akin to the humour of the Russian limericks, or *chastushki*, of the 1980s:

'The children in the cellar are playing Gestapo.
They tortured to death the plumber Potapov'.

To the drowning man the absurd in his desperation seems something stable to grasp at, because it concentrates the indeterminate circumstances of life down to their extreme. It is, of course, a form of suicide. Here, just as in suicide, there is the iron logic of rational inversion. If Utopian lifeshaping resulted in Socialist absurdism, perhaps building designs on the basis of the absurd will allow us to return to the lost truth of life? Hardly. Reasoning 'a contrario' does not work in architectural terms. Robert Venturi's demands for 'contradiction and complexity' contrary to the strivings of the functionalists towards logical simplicity are an example of this: it later became clear that the 'contradictory' structures of the Post-Modernists, including those of Venturi himself, were much more schematic than the structures of the functionalists whom they had accused of schematising. Schemes remain schemes, even if they are schemes of chaos.

Earthly Reality

So the question arises: how do the paper architects survive in reality? First of all, naturally – by their talent. But talent is not enough. Many with talent have been unable to find a niche in life – Van Gogh for example. The Post-Modernist artistic elite, including the paper architects, do not share Van Gogh's fate.

Even assuming that Van Gogh's work was in its way an experiment, then it was an experiment which Van Gogh conducted by himself on himself, whereas the paper architects preferred to work under laboratory conditions. The idea of laboratory art, which was unusual at the end of the nineteenth century had become natural by the end of the twentieth

Brodsky and Utkin, *Columbarium Habitabile*, 1989-90, from Projects portfolio, 1981-90, 109.2x80.6cm, etching, photo D James Dee (Ronald Feldman Fine Arts, New York)

and it is easy to see why. Amongst other critics, Mikhail Tumarkin underlined this aspect of paper architecture in his article 'The Roadside Picnic or Preparing for the Future'; the laboratory is the place where the future is prepared by degrees. The conceptualist laboratory absorbs and recycles both theory and criticism, which means that conceptualism and its spiritual relation, paper architecture, are self-sufficient – they do not need criticism, although they do need a means of communication. Paper architecture reports unilaterally to the world through exhibitions and journals, in which the architects' inner contemplativeness is translated into external spectacle. But architecture is valued today uniquely in terms of photogenicity.

The world of leisure is underpinned by the visual. Paper architecture lives by the energy of this world, and not only because it is oriented towards exhibitions and carnival. As opposed to the architectural avant-garde of the beginning of the century, the group is totally disinterested in industry and uninspired by labour. The only traces of industry left in their designs are the forests of smoking chimneys, the symbolists' favourite motif for the big city – the city which, incidentally, spawned the whole leisure world. However, contemplation and leisure, according to Aristotle, are the beginning and the end of any enterprise. Coinciding in paper architecture, these two points turn it into a circle, if not of like-thinkers, then of friends, contemporaries, comrades in . . . success.

Socially, the shape of paper architects' lives is determined by their club and their endless Moscow parties. But this is no simple club, it is an élite, and the élitism which the paper architects have bought by their mastery, originality and paradoxicality has pushed them closer to other élites. In the West the artist aims ultimately to become a millionaire, to enter the financial élite. In the East, the artist would approach the ruling élite. Ilya Glazunov is an example of the drawing together of these two tendencies in Russia, but the number of places of this kind is so limited that the majority of Soviet Post-Modernist artists have preferred to emigrate. Nevertheless, the theme of the closeness of Post-Modernism to power has remained in Russian life. Paradoxically, it has recurred in the form of one of the most sinister figures of the current political firmament Vladimir Zhirinovsky. In Simeon Faibisovich's view, a former architect and artist who was closely involved with Post-Modernism, Zhirinovsky openly unites the principles of the Post-Modernist game with popular clichés in his political agitation. And now that Russia has embarked upon the road of capitalism, some of the paper architects who remained there have begun to serve the nouveau riche whose tastes, to judge by the designs of Dmitry Velichkin, are closer to kitsch than to Post-Modernism.

Indeed, paper architecture as a whole appears to be drawing apart from commercial Post-Modernism; the romantic element is too great. The real financial oligarchy prefers the cleanness of minimalist forms. Kahn's architectural archetypes, his squares and circles, have become in Post-Modernism the same denuded schemas as the skeletons of Avvakumov's staircases and Belov's regular grids.

Death and the Maiden

The elitist nature of Post-Modernism is expressed in the perfection of the building, perfection which manifests itself as a rule through the obvious exaltation of structure and line. The perfect building is the perfect subordination of materials to design. The paper architects' plans are a

Brodsky and Utkin, *Ship of Fools or a Wooden Skyscraper for the Jolly Company*, 1988-90, 74.9x75.7cm, etching (Ronald Feldman Fine Arts, New York)

141

form of homage to the perfection of the line, in which architectural archetypes are symbolically embodied. The signs drawn out on paper remain to this day symbols of the highest value. It is no accident that the metal coin was replaced by paper money, and that the financial aristocracy has superseded the industrialists. So the refusal to construct is not just a function of the power of the media-driven publishing and exhibiting culture, it is also a way of preserving the purity of the schema from adulteration by the rough imperfection of building work, a symbol of the draft's independence from reality.

The epithet 'paper' is both ambiguous and partly inexact. The point is not only the paper, the point is the devotion to pure ideas and pure forms. The point is the incorporeality of the plan. These architectural inventions lead us into the realm of spirituality, into another world, show us a parallel existence. In them we feel not only the texture of a dream but even the shadow of non-existence, of death, a feeling perhaps most distinct in the flawless classical perspectives of Mikhail Filippov. So any criticism of the paper fantasies is not only powerless, it is almost blasphemous, for one must never speak ill of the dead.

In Post-Modernist structures the power of the blueprint shows through in the complete subjection of the materials before the geometrical design. These buildings are dematerialised, composed only of lines, planes, volumes, spaces – not even of light, since light is closer to materials than is geometry. What the Germans called 'stoff gefühl' was neutralised by the late modern and post-modern white compositions. At the same time complexity and contradiction are also neutralised, for both of these imply reality of experience.

Ancient architecture was full of the feeling of reality, lying as it did on the border between life and death and expressing as it did a magical and transcendent element, a dramatic crossing beyond reality. But its otherworldliness never spilled over into superficiality, it was never the object of an isolated admiration. In the ancient world, the kingdom of the dead borrowed forms from life, whereas now we have life imitating the illusoriness of the kingdom of the dead. Ancient architecture belonged to a civilisation as yet unweary of earthly landscapes. Konstantin Mel'nikov was afraid of death and struggled with it. He tried to overcome death through dreams and created designs for special dormitory-bedrooms which would be like sleep factories and, perhaps, factories of dreams. But architecture cannot give man eternal life, it can only free us from the fear of death, the fear of emptiness and non-existence, which from time to time visits us in nightmares. And the best way to escape a nightmare is of course to wake up. There is, however, another means of neutralising the conflict between nightmares and life, and that is to turn life itself into a nightmare. This way lies suicide. We have before us something similar in the work of the paper architects, although this is a specific sort of suicide – professional suicide.

Such a joyless conclusion is, of course, out of tune with many sides of paper architecture – the enthusiasm of the paper architects for teaching in special children's architectural schools, for example. So perhaps the theme of professional death in their designs is only one of the poles of a more complicated conceptual structure of significations? Perhaps I am wrong in lumping my own suspicions that Western Post-Modernist architecture is on the point of death together with the dark irony of the paper architects' inventions. Perhaps it is even true that Post-Modernism

is not moribund – perhaps this is just another visual aberration. Perhaps the tragic conclusion I have come to is itself a manifestation of post-modern extremism and all of my criticism is no more than just another 'paper' fantasy. I hope this is not so, but am ready to allow the possibility of such an interpretation. Were this the case, I would have to conclude it with a fairy-tale motif, and say that architecture is not dying, neither in paper dreams nor in reality, but is sleeping the sleep of Sleeping Beauty in her 'crystal tomb' and that a prince must come and kiss her for her to awake. Can one hope things will end thus?

Some years ago in Rumania something real did occur, something which was reported in all the papers, something which prompted an unexpected conjecture on the origin of one of Grimms' fairy tales. A necrophiliac who abused the body of a young girl lying in a hospital morgue woke her out of a deep lethargic sleep. One might ask whether this architectural lethargy might not be overcome in a similar way?

Postscript

However, is not this whole discussion in itself a version of the Post-Modernist performance, just another set of critical ramblings? I am not in a position to judge. But where are the criteria of common sense and madness, where the borders between reality and invention, Utopia and fairy tale, myth and introspection, life and its deathly counterpart, the animated and the inanimate?

Neither paper architecture nor Post-Modernism can supply answers. But perhaps their historical mission consists only in leading us up to that line beyond which we can no longer pretend that these questions do not play a role in professional affairs.

LEFT: Dmitry Velichkin, Red House, private residence, 1989